ISLANDS OF EDEN

St. Vincent & the Grenadines

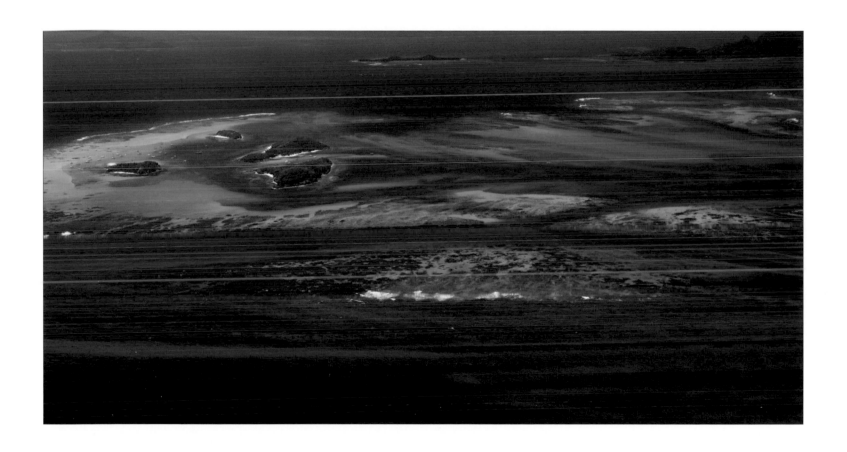

Also By Ferenc Máté

ISLANDS OF EDEN
St. Vincent & the Grenadines

Photographs and text by

FERENC MÁTÉ

ALBATROSS BOOKS
at W.W. NORTON & CO. 500 FIFTH AVE. NEW YORK

To all the people of St. Vincent and the Grenadines
without whose exuberant joy of life this book would not have been born.
Lime on.

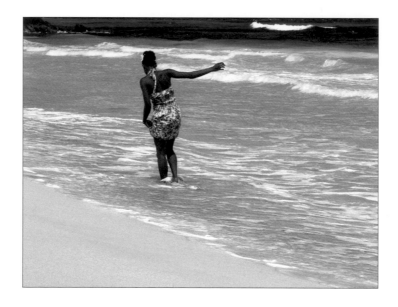

Printed in Italy
First Edition
ISBN 978-0-920256-83-1

Albatross Books at
W.W. Norton & Company Inc., 500 Fifth Ave, New York, N.Y. 10110
www.wwnorton.com
W.W. Norton & Company Ltd., 10 Coptic Street, London WCA 1PU
1 2 3 4 5 6 7 8 9 10

Contents

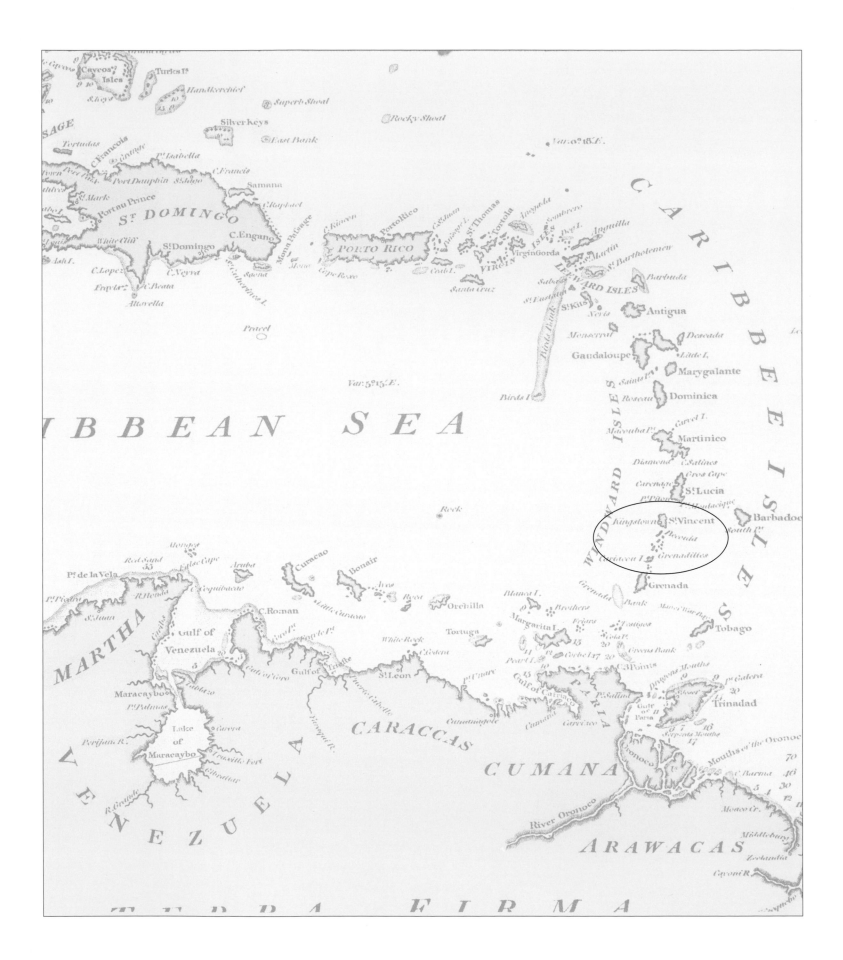

PHOTOGRAPHER'S NOTE

Sometimes it takes a while to see the forest from the trees. It happened with these islands. I had been photographing for nearly a month: the waterfalls, tropical jungles, and the volcano on foot; the silent beaches and coves from a sailboat; and the atolls and coral reefs from an old two-seater, high-winged airplane with the door removed, and me strapped to the worn aluminum floor.

It was all breathtaking—the colors, the shapes, the light—but not until I began to shoot the small hand-worked farms on the steep hillsides, and the stalls of open markets awash with an endless variety of perfectly ripened vegetables, fruits and spices, and saw the fish market heaped with seafood of every shape and color, did I begin to realize that this chain of islands was like no other.

When I began photographing the people, feeling their easy warmth, ready laughter; hearing their music and song, seeing their joy at meeting one another, happy to pass the hours just being together, it dawned on me. This is a forgotten Eden.

—Ferenc Máté

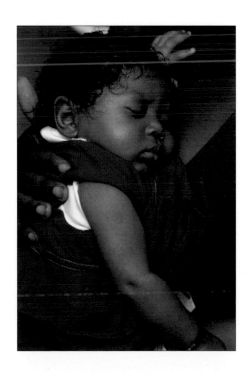

ARANIQUE

When I was six years old, my parents took me on a visit to one of our local tourist attractions, the Botanical Garden. On that day, I think I was the youngest child in the oldest garden in the Western Hemisphere, and also the naughtiest.

I ran up and down and rolled all around on the green, grassy lawn. I also did something I wasn't supposed to do. I picked the flowers. They were very beautiful. Unfortunately, my mother caught me and scolded me and made me promise never to do it again, but on my next visit when I thought that no one was watching, I did it again and again. I picked the red flowers, the white flowers, pink and yellow flowers until I had a beautiful bouquet.

St. Vincent and the Grenadines is like a beautiful bouquet, made up of 32 islands and cays grouped together like flowers in a bunch. This island paradise is my home and home away from home to thousands of visitors each year.

—Aranique Jackson, Age 13
Kingstown Preparatory School

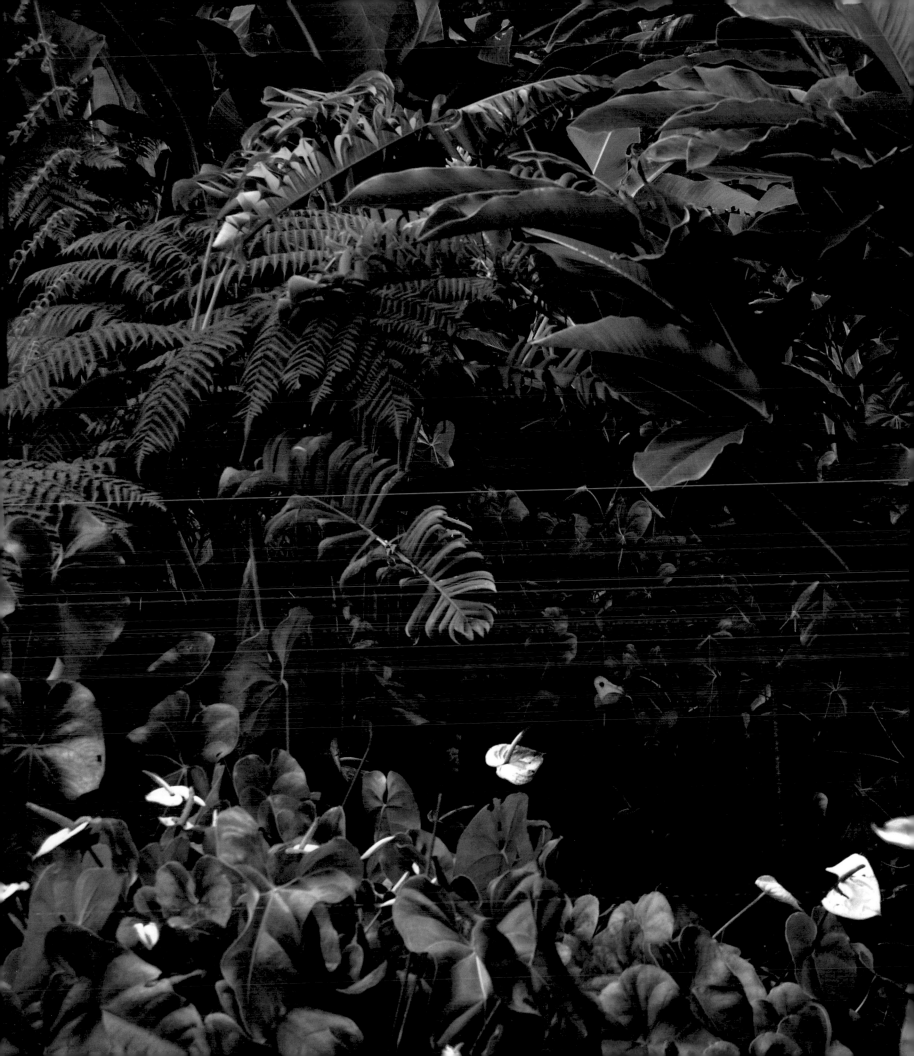

VINCY VISTAS

IF I WERE IN THE "CREATION BUSINESS" and my assignment was to come up with the idyllic country, I would be hard pressed to improve upon St. Vincent and the Grenadines.

This archipelago lies in the center of the Eastern Caribbean, with the deep blue Atlantic Ocean on its windward side and the turquoise Caribbean Sea on its leeward. The country's 32 islands and cays, straddling the 13th North Parallel, begin about 90 miles off the coast of South America.

From top to bottom the country is 37 miles long, but most of those 37 miles is water. Of what land there is—the island chain—only nine are inhabited, bearing intriguing names like Bequia, Canouan, Mayreau and Mustique. The largest island, St. Vincent, is 11 miles long, but with a 4,048 foot-high volcano at its center and a steep coastline dotted with coves and bays, the drive up the island's narrow, roller-coaster road takes nearly two hours. And that's on a Sunday morning without another car in sight.

The Vincentians (they call themselves "Vincies") hold their largest island in enormous respect; even though it's a whole mile shorter than the island of Manhattan (or a total of 24 subway stops), they refer to it as "The Mainland."

Warmed by the sea and ventilated by the gentle trade winds, the islands have a climate that's the envy of the world. Daytime temperature is a barely varied 85 degrees Fahrenheit; at nighttime it is 78. That's winter. What this means is that your entire year-round wardrobe can consist of a shirt and a pair of shorts. If you're a clothes horse, you can add sandals.

"The Mainland's" La Soufrière volcano acts as a rainmaker. Clouds that approach, climb its slopes, cool, then drop their moisture. Rain. Enough to sustain rainforests and huge waterfalls, enough to cool off hot days, and enough to irrigate the fertile slopes and valleys, the largest of which is aptly named *Mesopotamia*.

THE LANDSCAPE OF EVERY INHABITED ISLAND of the chain is relentlessly dramatic. Steep valleys run to the sea. The coastline alternates between craggy headlands and deserted black sand beaches in the north islands, and soft pink, but just as deserted beaches, in the south. The rugged hills yield long vistas out to sea onto desert islands and vast sunrises and sunsets.

St. Vincent's lush tropical rainforest has towering waterfalls, enormous trees and plants, dangling vines, dazzling flowers, and noisy parrots.

The other islands are lower and less rainy and range from lush valleys to desert hills and a coastline bathed in sunshine. A beach-lover's dream.

But the jewel of this country is its national park, The Tobago Cays, a collection of tiny atolls, long sandbanks, coral reefs, and giant turtles. The hues of its warm waters are infinite and changing with each passing hour, every passing cloud. I photographed the Cays one afternoon—circling, weaving, mostly gliding, in that old, door-less small plane, flying barely mast-high over sailboats. When I landed, I felt I had just lived one of the most enchanted times of my life.

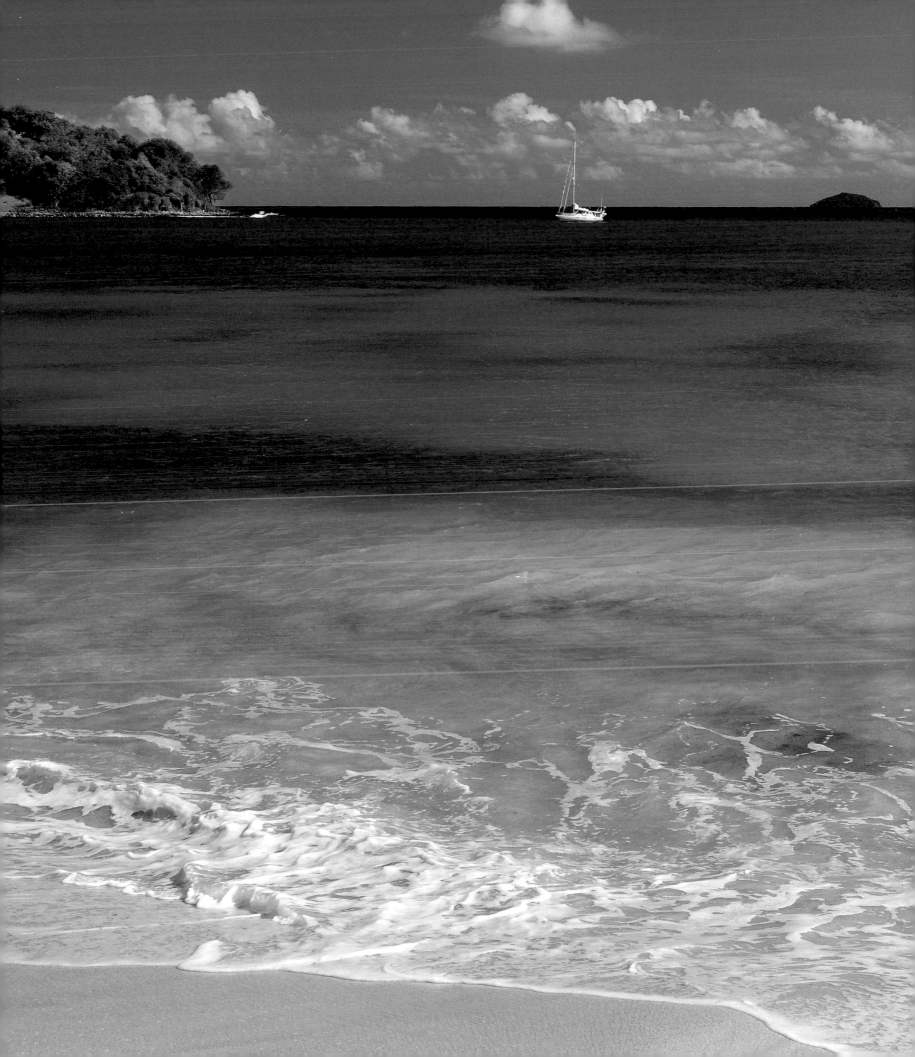

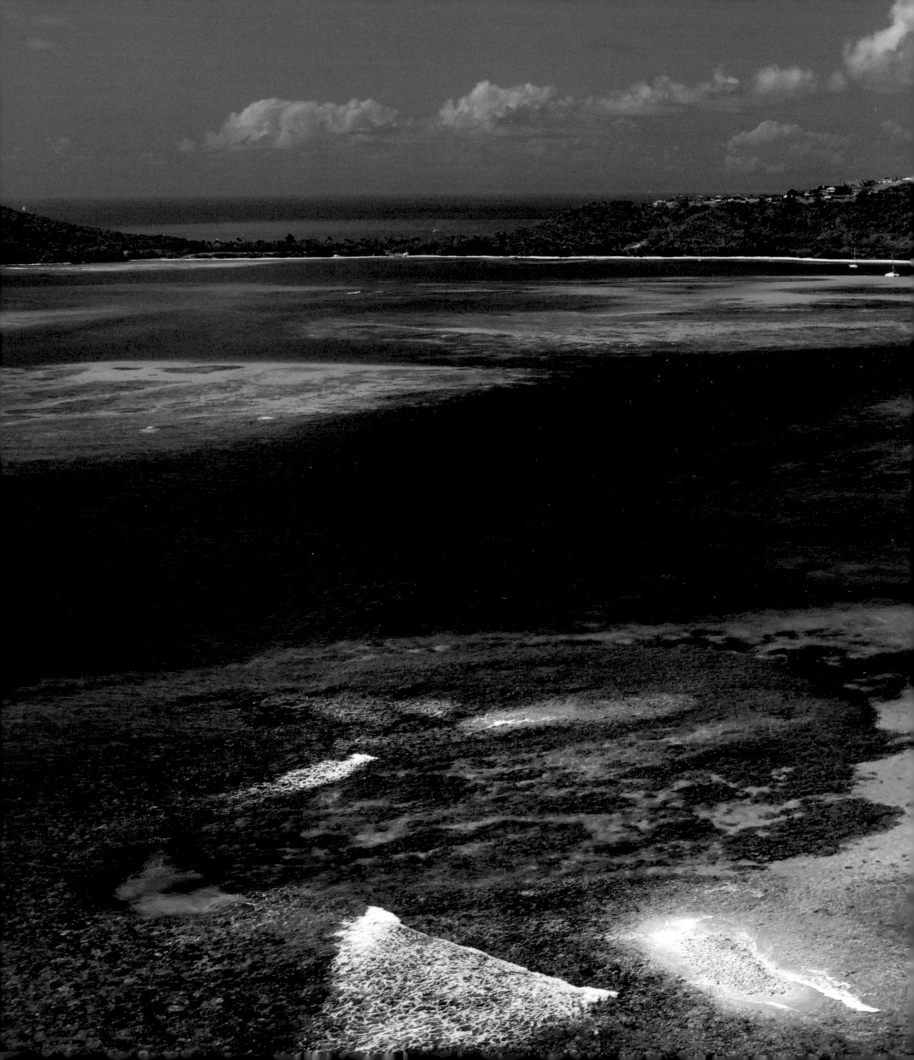

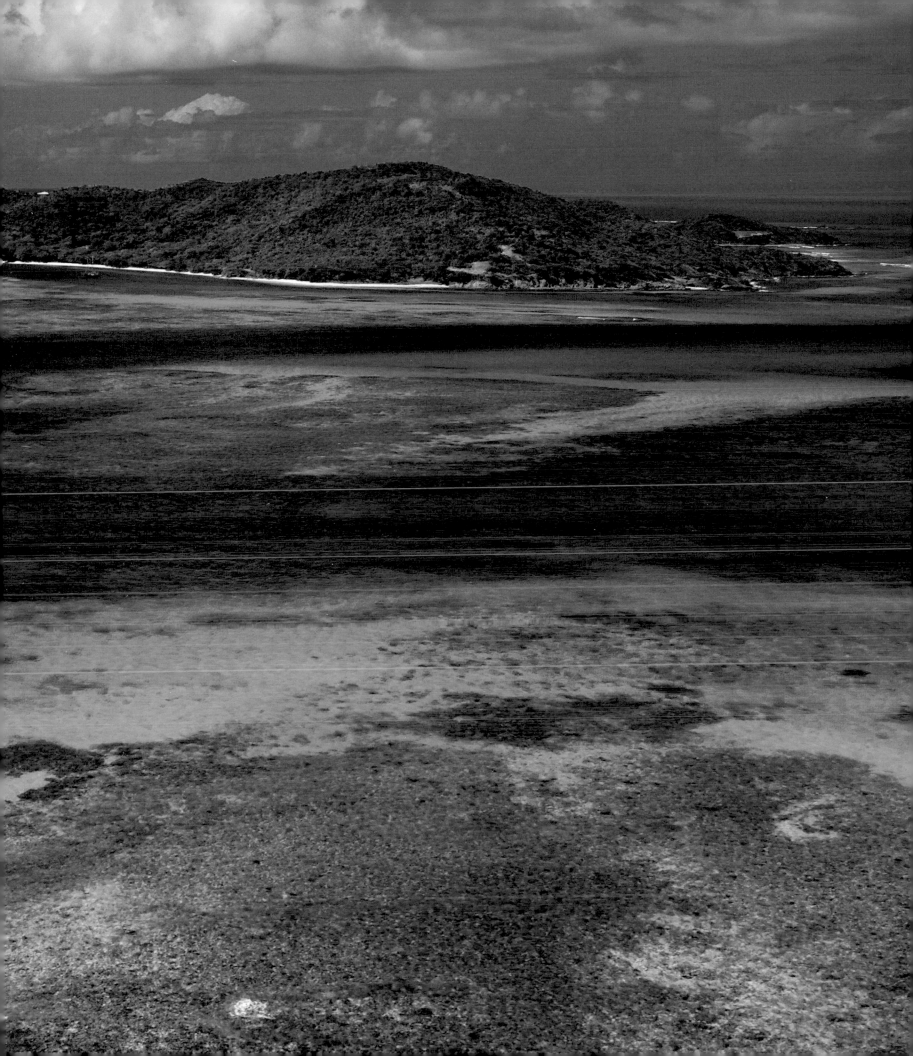

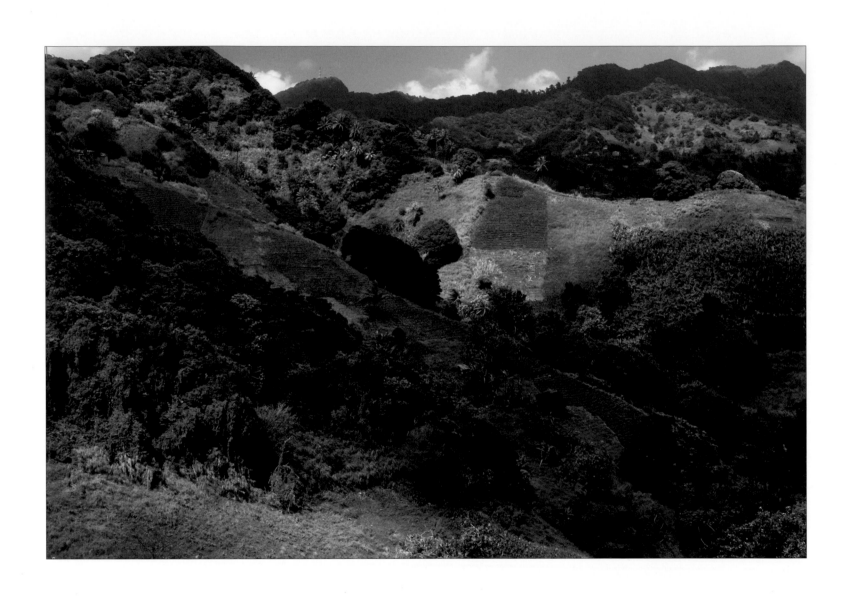

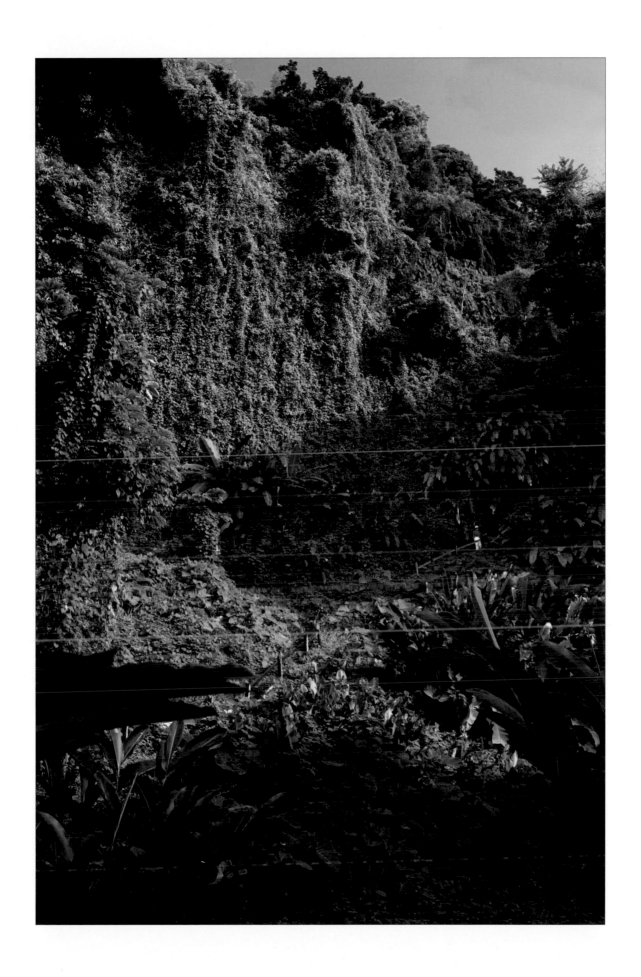

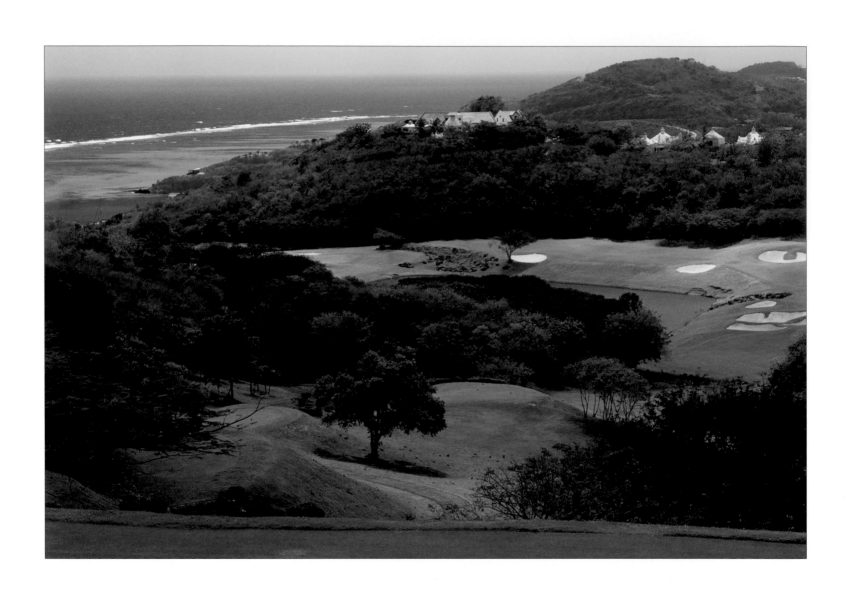

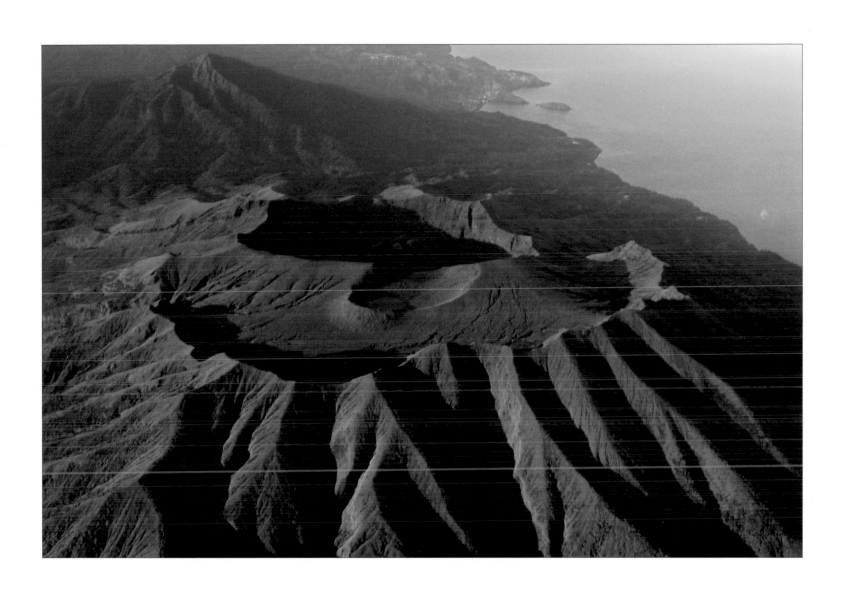

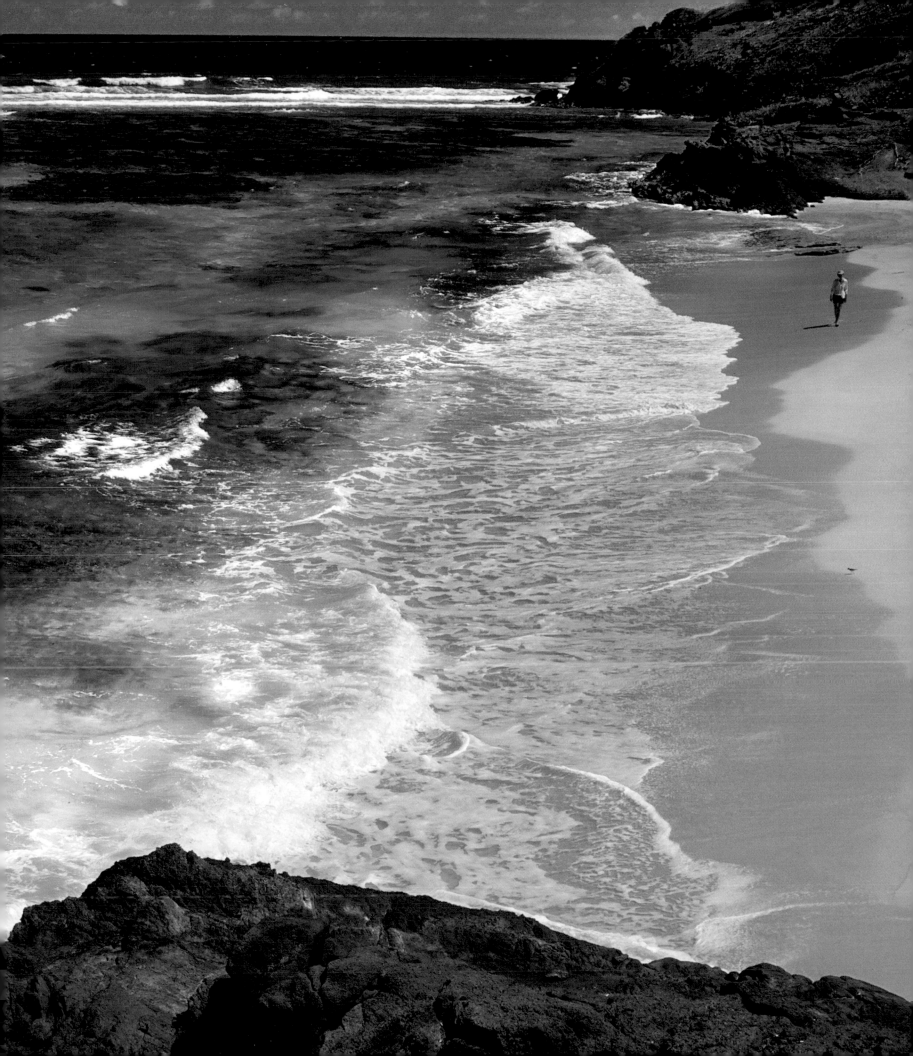

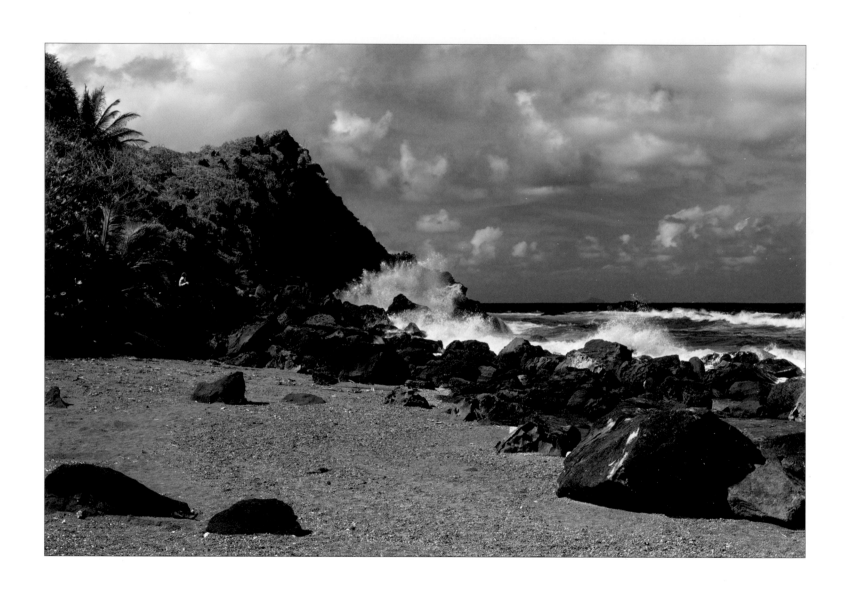

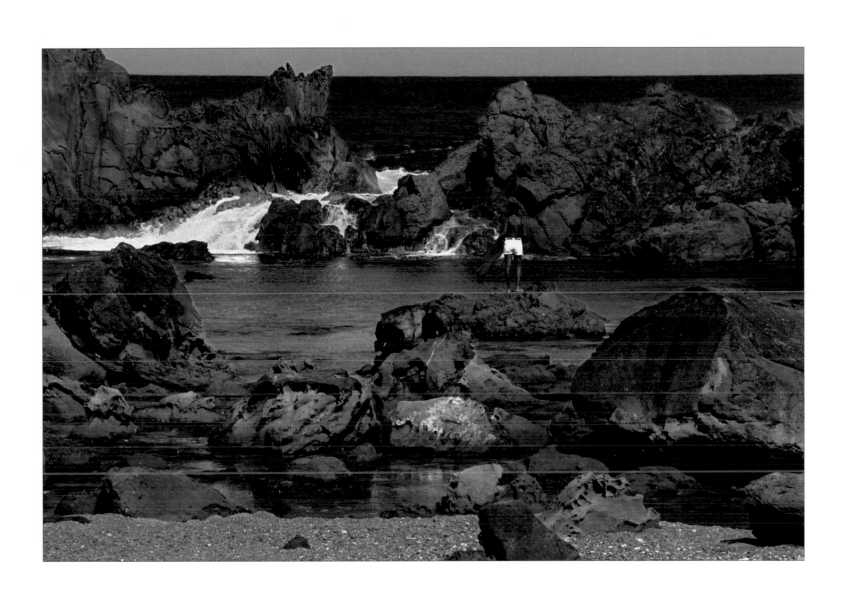

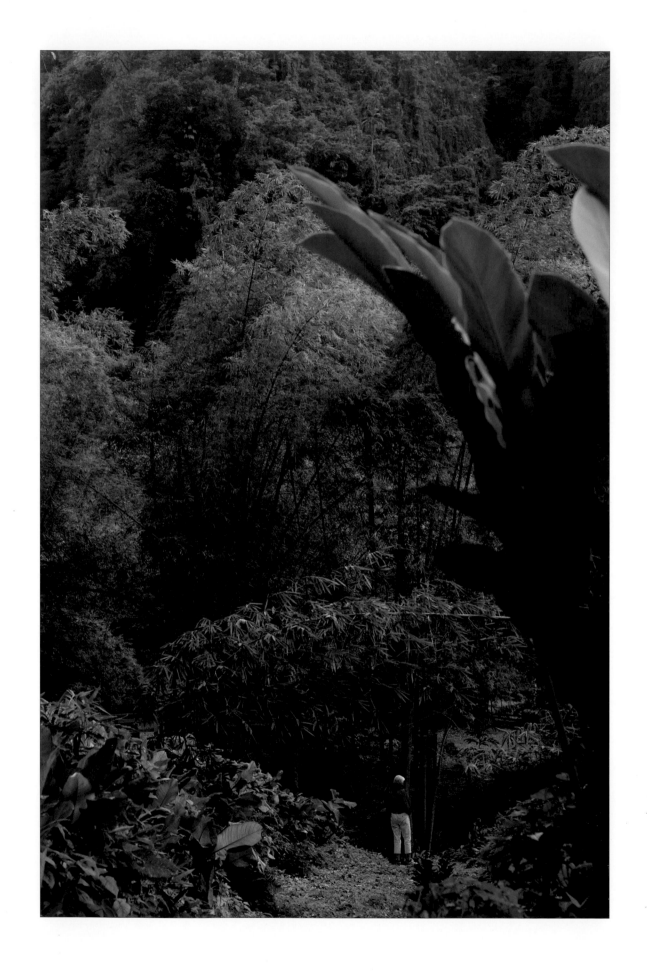

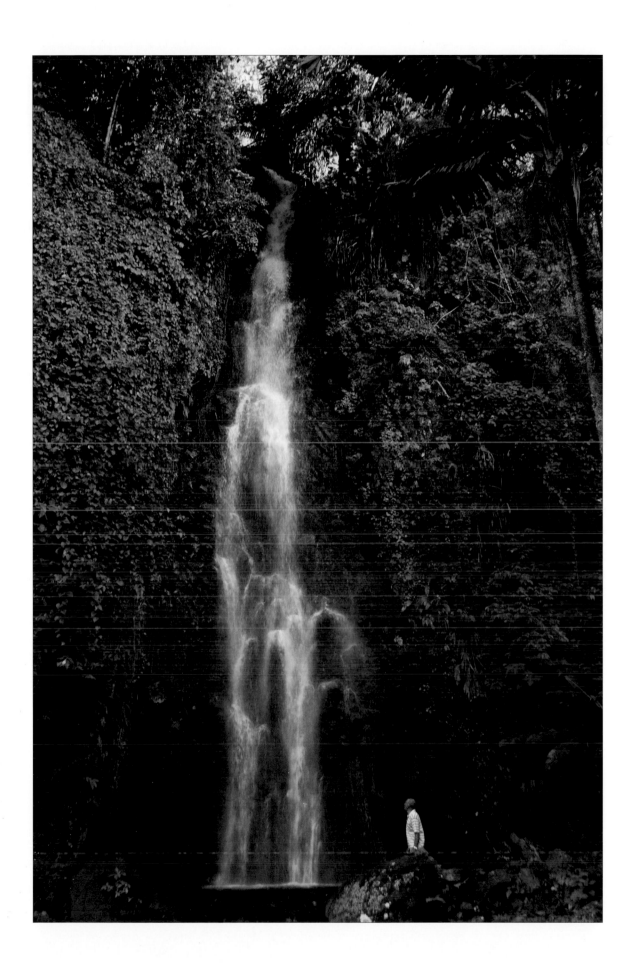

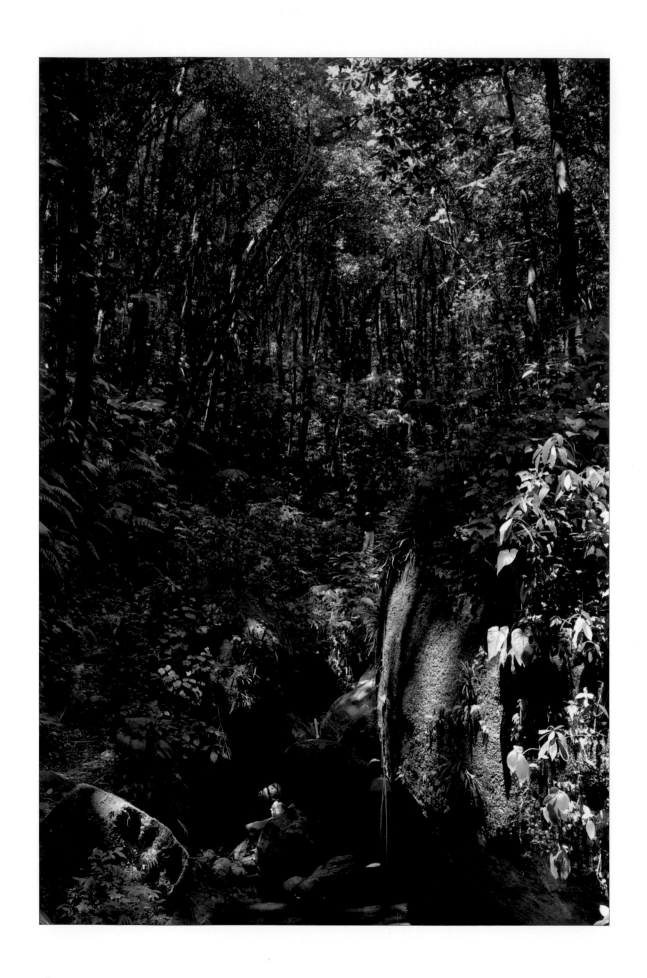

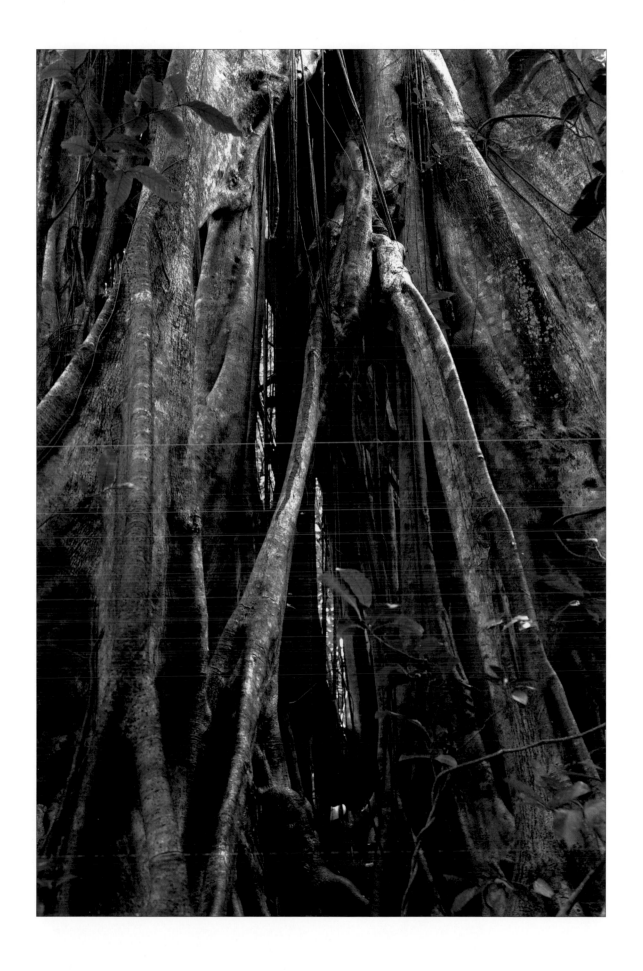

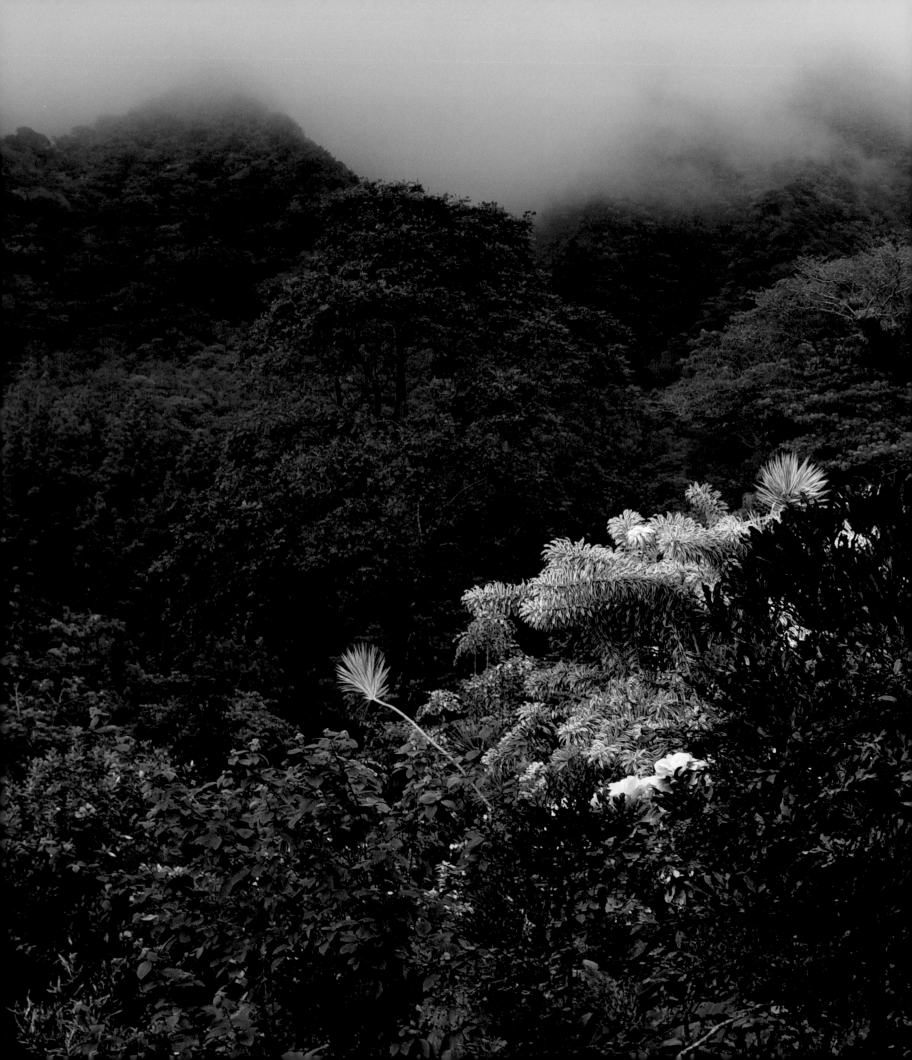

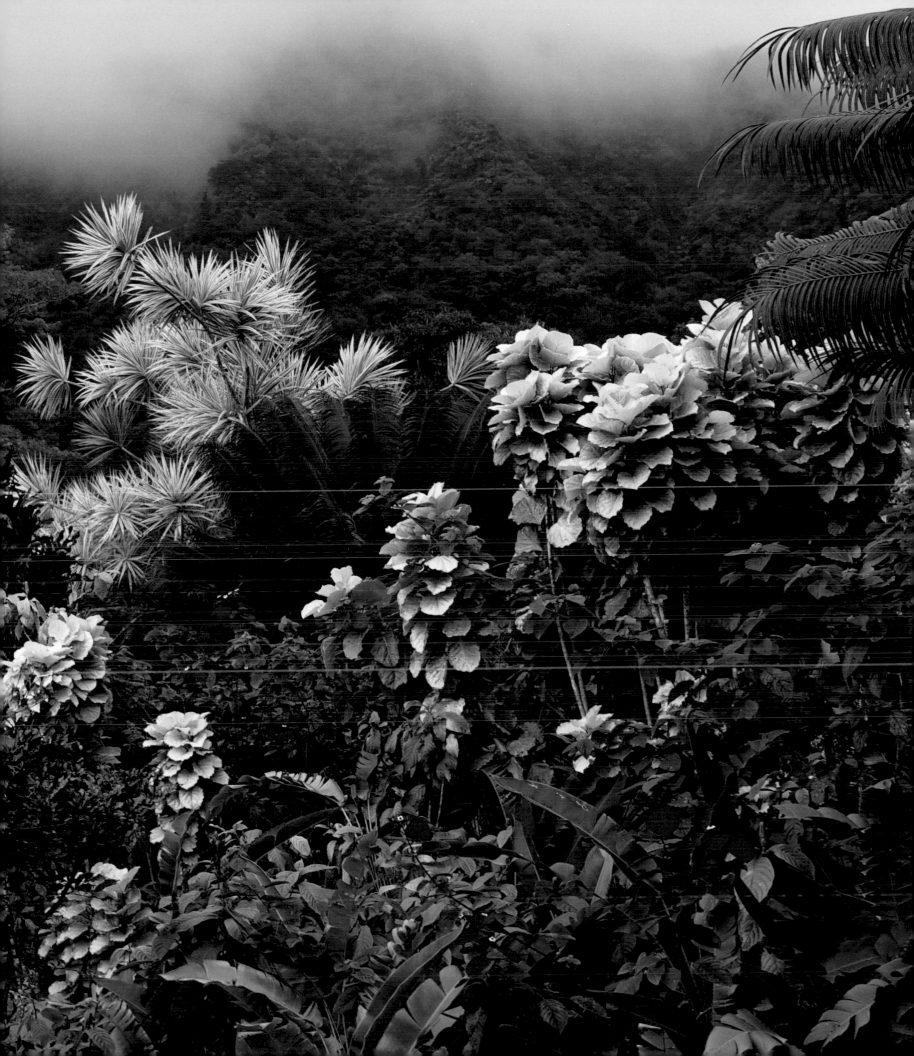

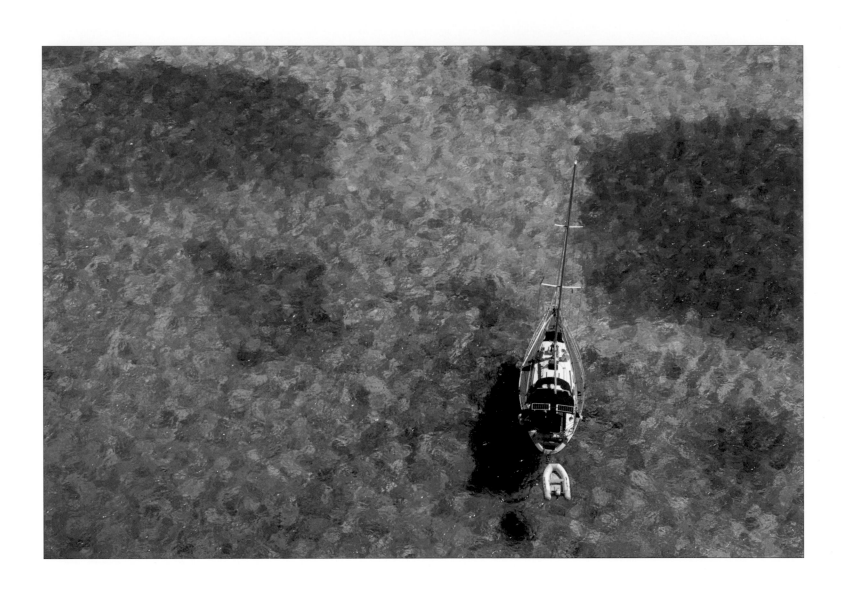

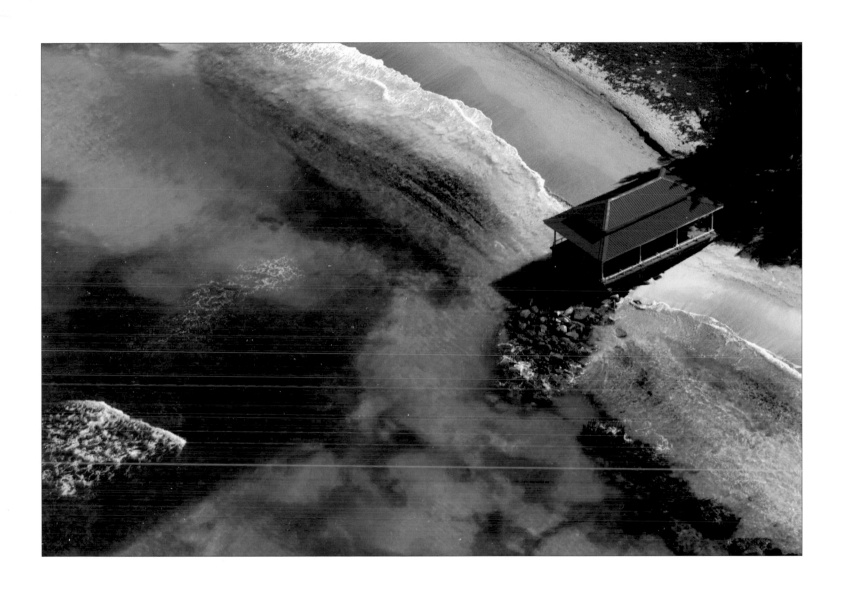

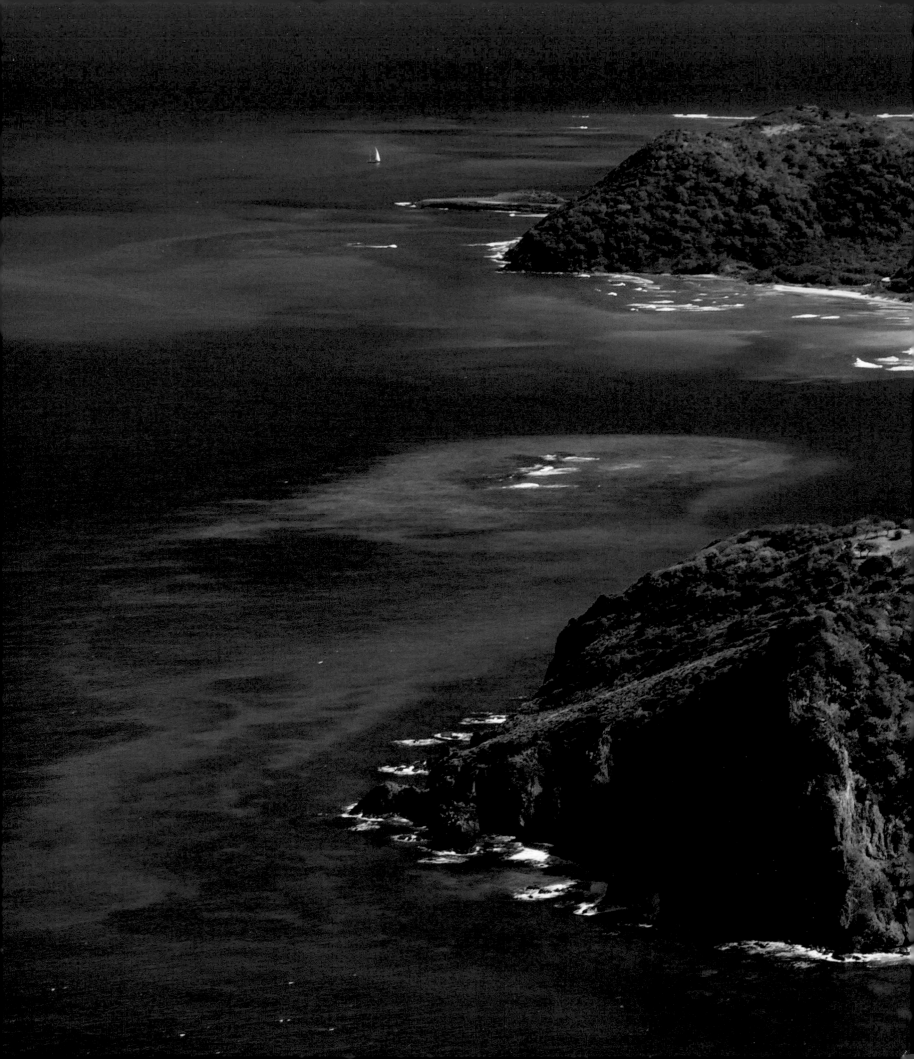

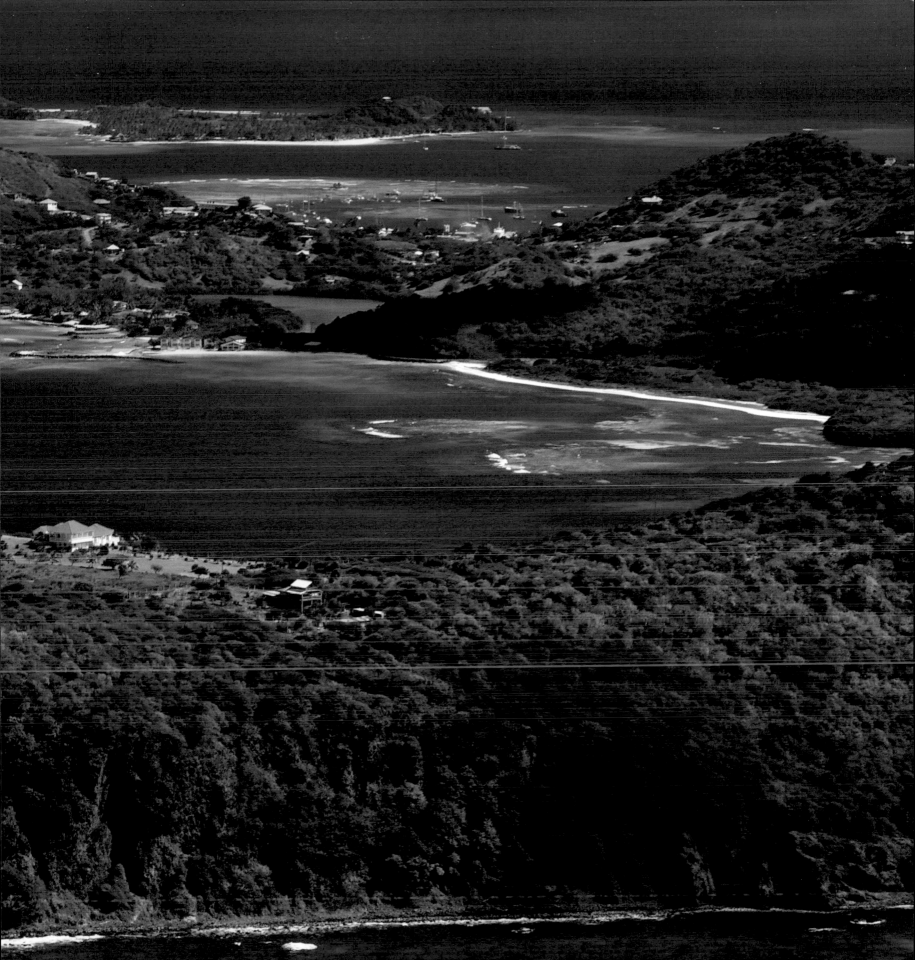

VINCY FACES

BUT THE MOST WONDERFUL SURPRISE in these islands is the people. Their incomes are modest but you don't need much money when you have perfect weather, fresh food in abundance, and natural beauty all around you. And while their GNP might be meager, what they are rich in—as rich as I have seen in my travels—is something infinitely more important than GNP. It's that rare treasure JOL: Joy of Life.

And Joy of Life is not measured in numbers. It is measured in a feeling in your heart. It is measured in how welcome you feel among a people: how quick and sincere are their smiles, how deep and joyful their laughter, how trusting, and attentive their gaze, how earnestly they help a stranger, and how easily they come together to chat or sing or dance.

I found an exuberant Joy of Life in all age groups, in all walks, from kids to grandmas, from farmers and fishermen to government officials. There was an immediacy, a warmth, an openness, an eagerness to help. And a readiness to laugh. Easily and deeply. And to hang out. They call that "*liming*." But more about that later.

I found a Joy of Life in the contented calm of farmers who, after a few words, offer you whatever they have harvested, or fishermen who invite you to join them—with nothing to be gained except your company—in their wooden skiffs on a trip many miles offshore, leaving at five in the morning, to fish for tuna and dive for lobster. And I found it with city folk like the large, serious lady at the market who assigned herself as my director of photography, cheerily but firmly shepherding all—from school kids, to street vendors, to passersby—out of my photos or into them.

And they are a proud people. Many are descendants of the last Carib tribe whom the British managed to subdue brutally only at the end of the eighteenth century. Their pride shows on the tiny but meticulously kept farms, in the tidy towns, their freshly painted fishing boats, and in the woodworking prowess of Bequia, famed for building seaworthy schooners.

As for their character? Two short anecdotes.

I was shooting on the working docks of Port Elizabeth, Bequia amid the noise and bustle of dockworkers loading fishing boats, ferries, and tramp-freighters. I changed cameras to one with a longer lens, then closed up my camera case and went on my way. A few hundred yards later I stopped to take a shot of the Bequia Bookstore. I opened my case and almost fainted. A camera was missing. With its new zoom lens it cost over $4,000. I ran back. Frantically. The docks still swarmed with people. I passed a group of men playing cards in the shade. One called out. "You forget something?" They laughed. I looked around where I had last taken shots. The card-shuffler yelled to me, "Over on the big mooring cleat!" And there was my camera, exactly where I had left it.

A year later, this time in the harbor of Union Island, I put my laptop on a fruit stand to free up my hands to take some pictures. Then, as I'm wont to do, started chatting about God-knows-what with God-knows-who, got offered a beer, had fun, went home. I only noticed something was amiss the next morning. I went to check my email and found I had nothing to check it on. You guessed it: I ran. The fruit stand was closed. No one around. But the bartender from the hotel called out to me. "Is this yours?" And held my MacBook in the air.

When you consider that each of those items is worth roughly the annual income of a local framer or fisherman . . . As I've been telling you: Paradise.

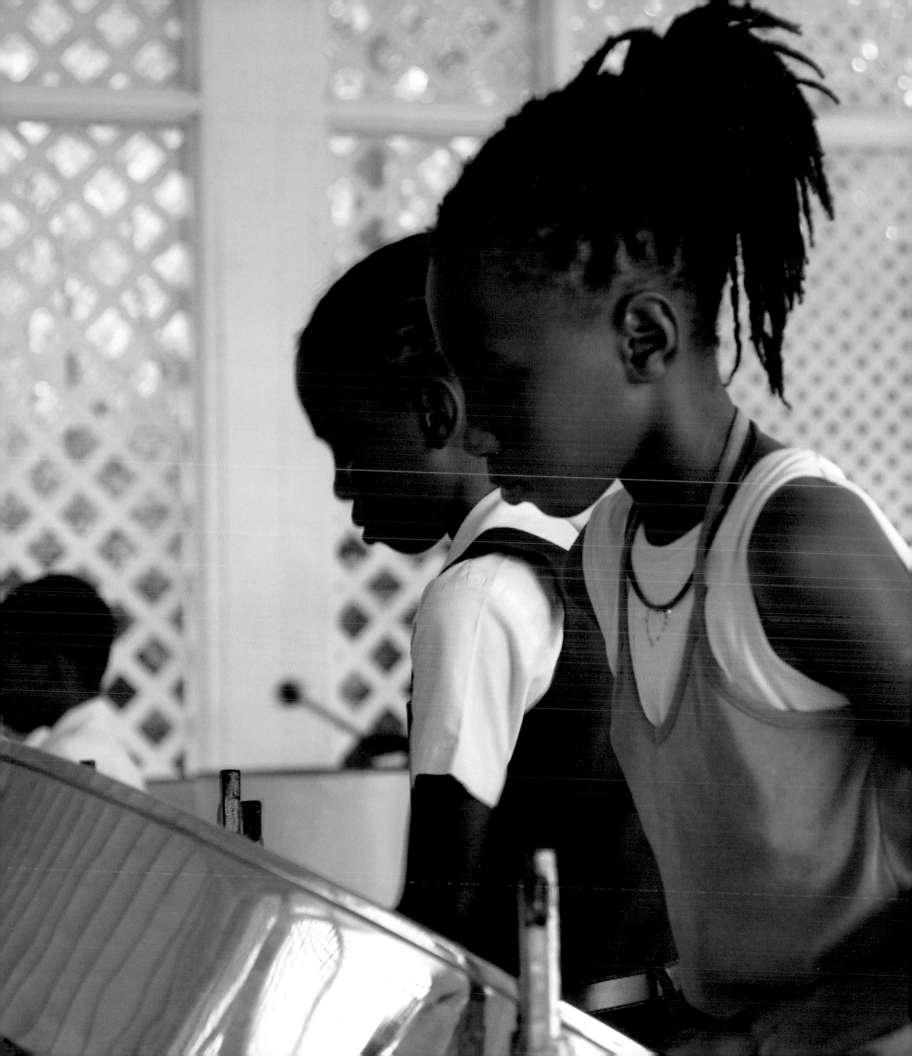

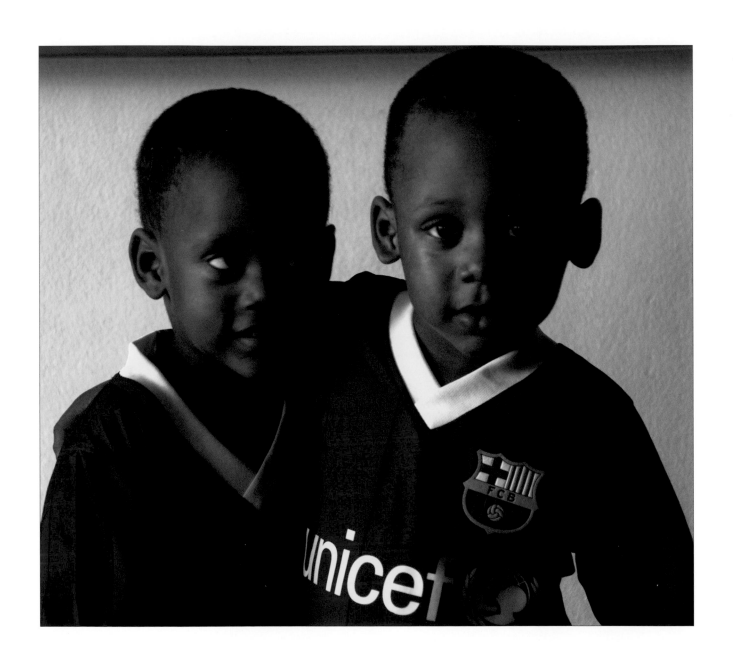

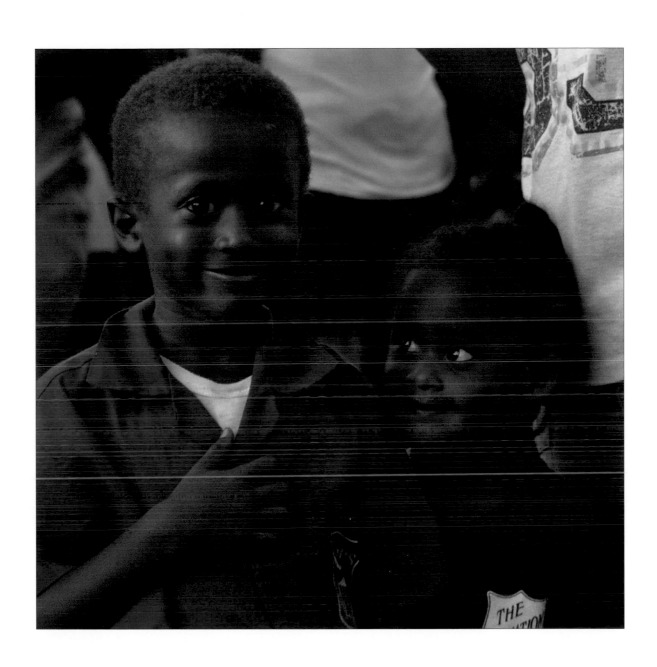

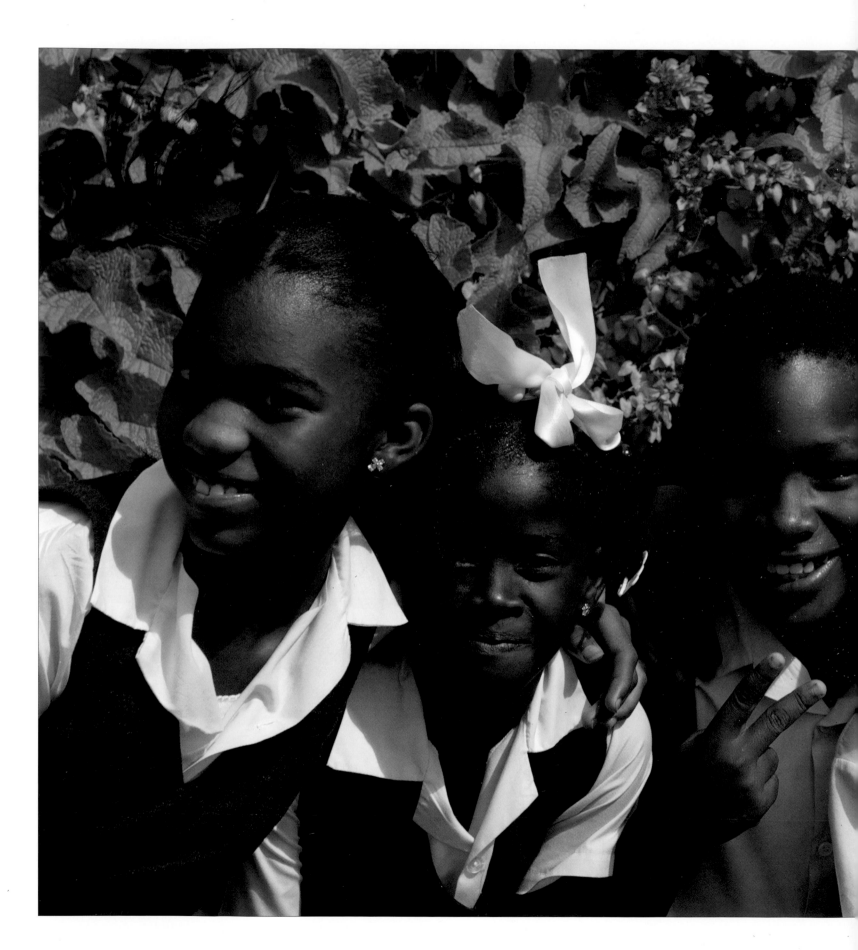

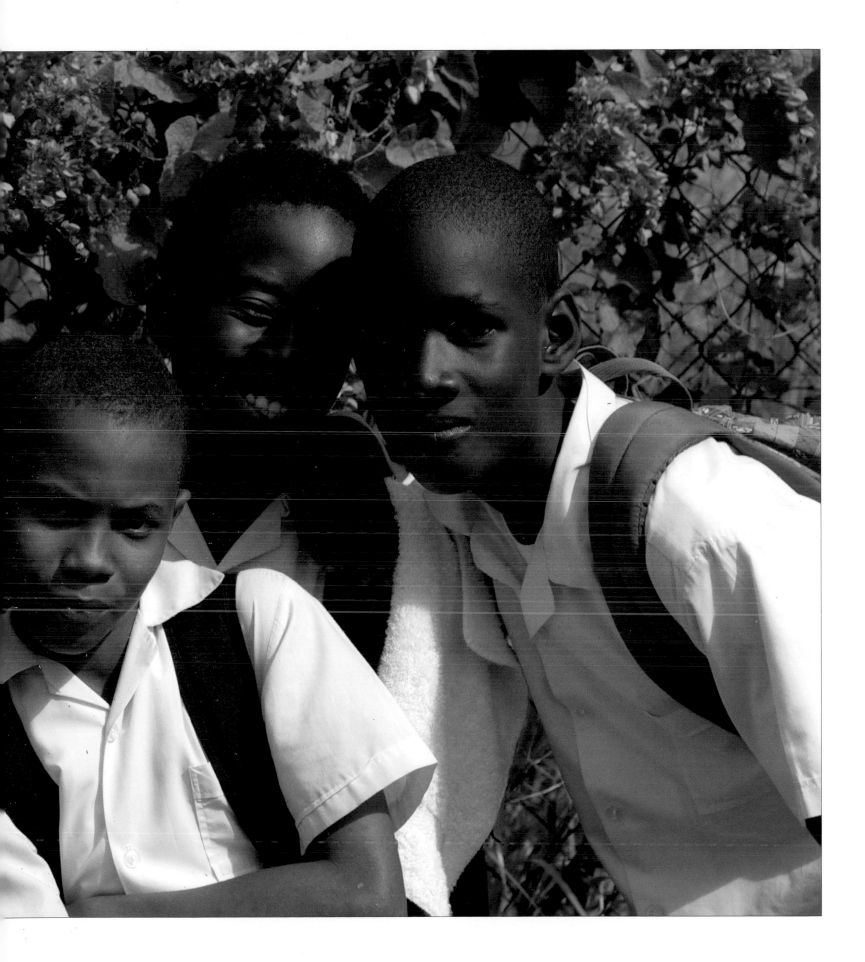

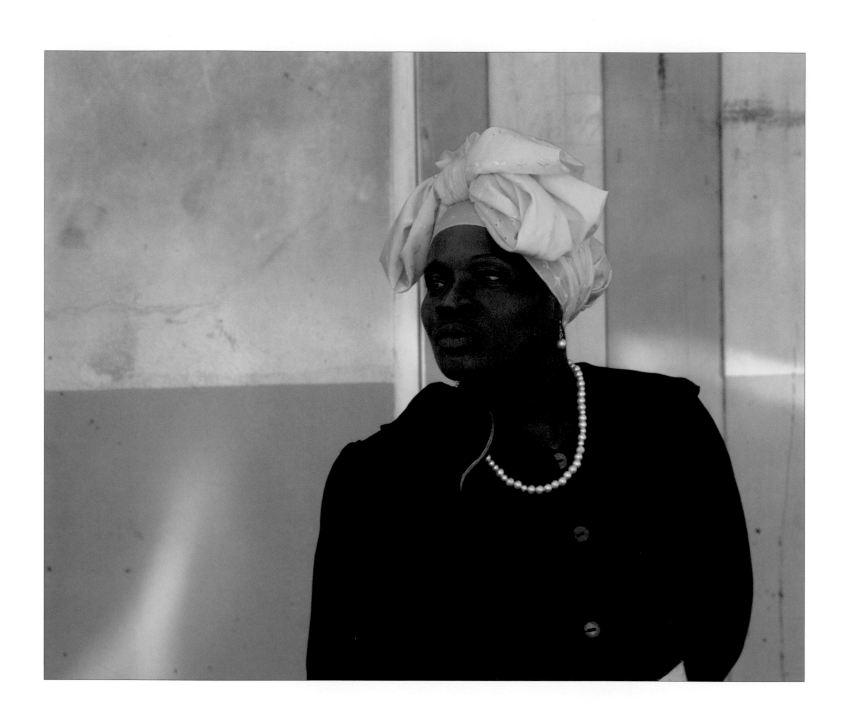

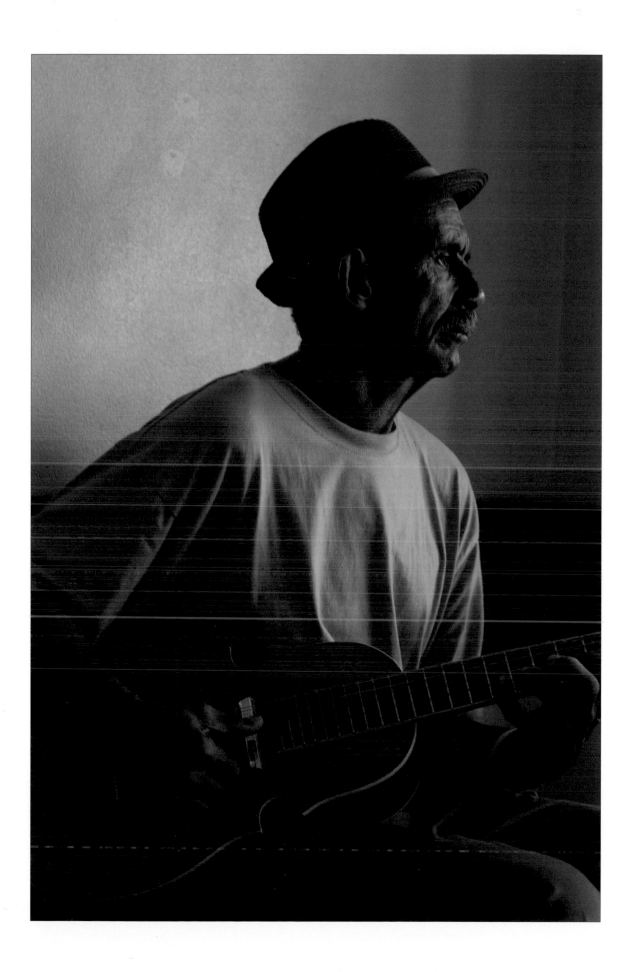

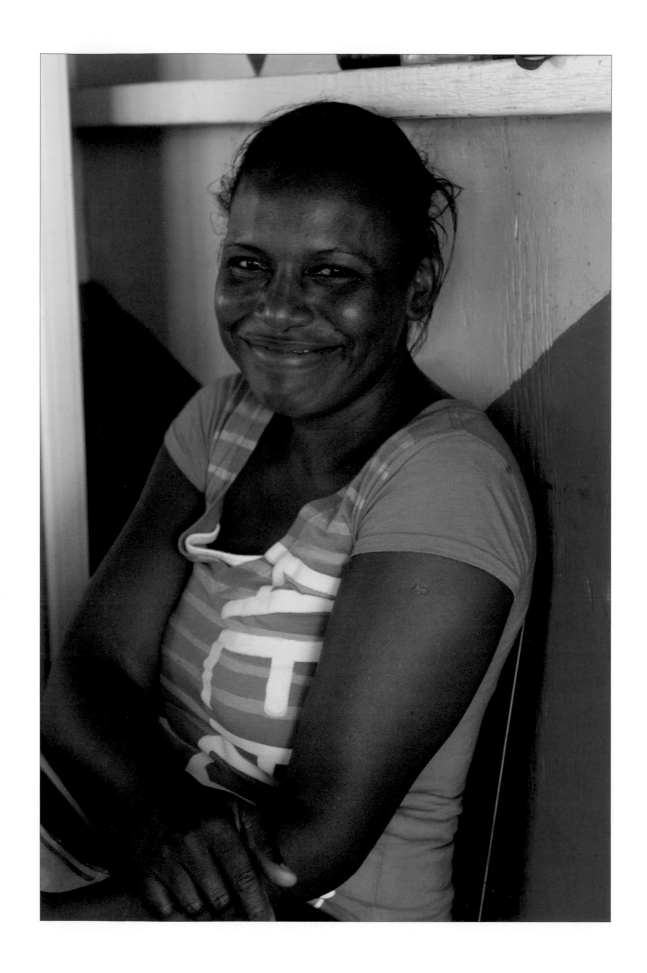

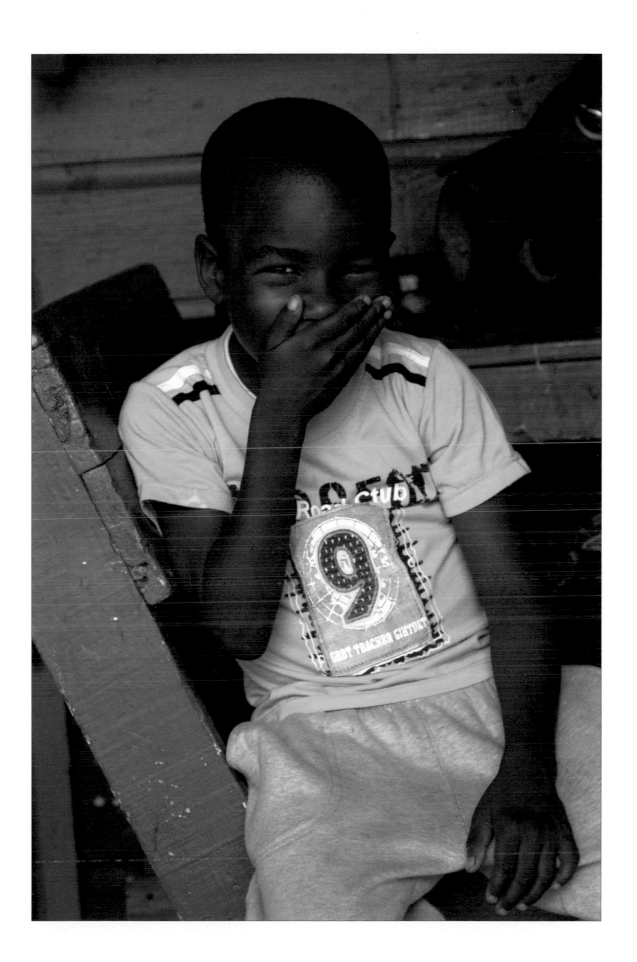

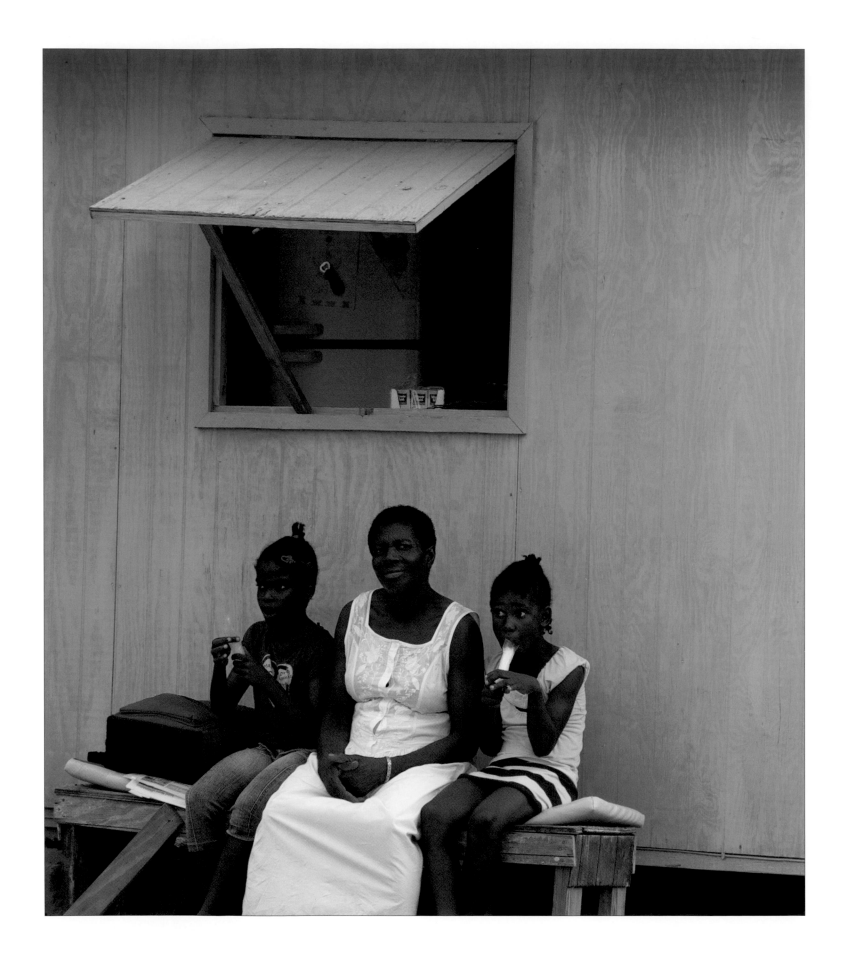

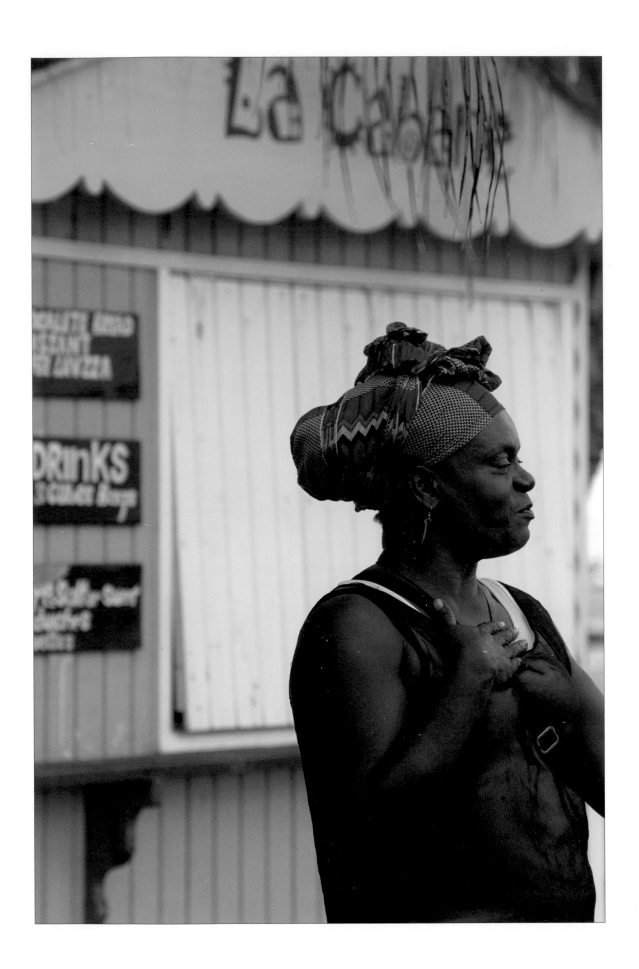

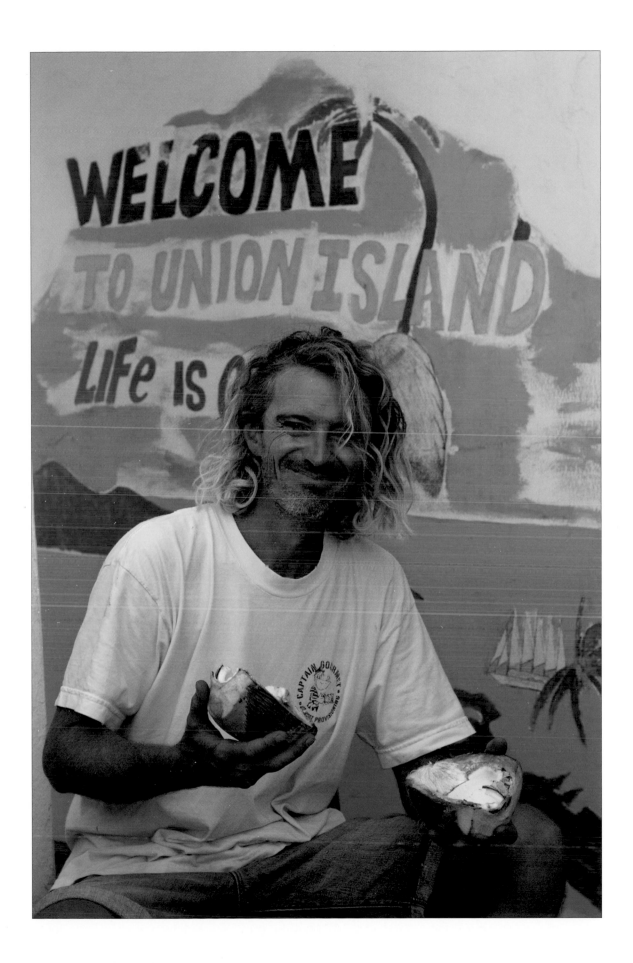

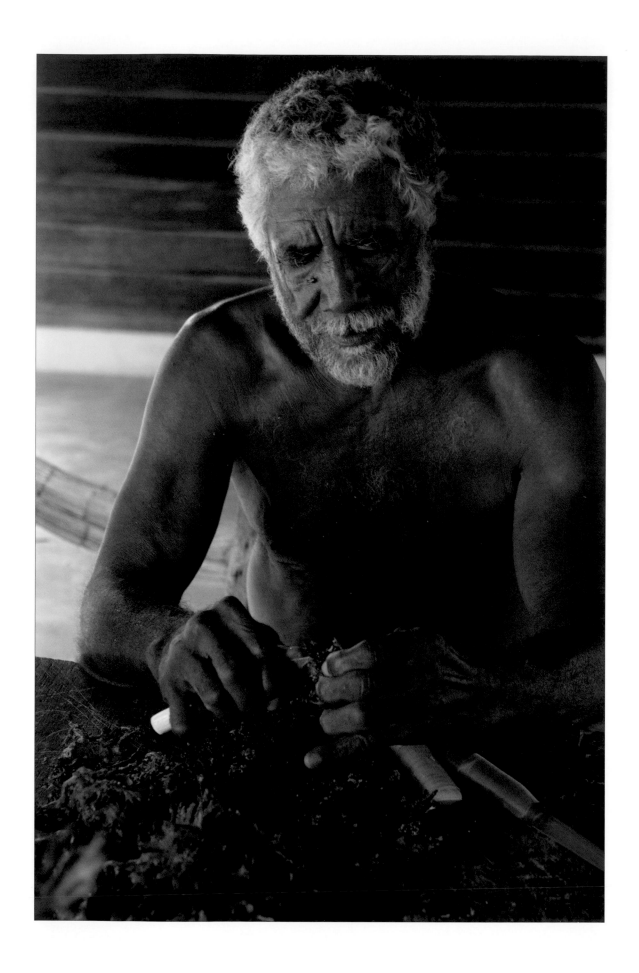

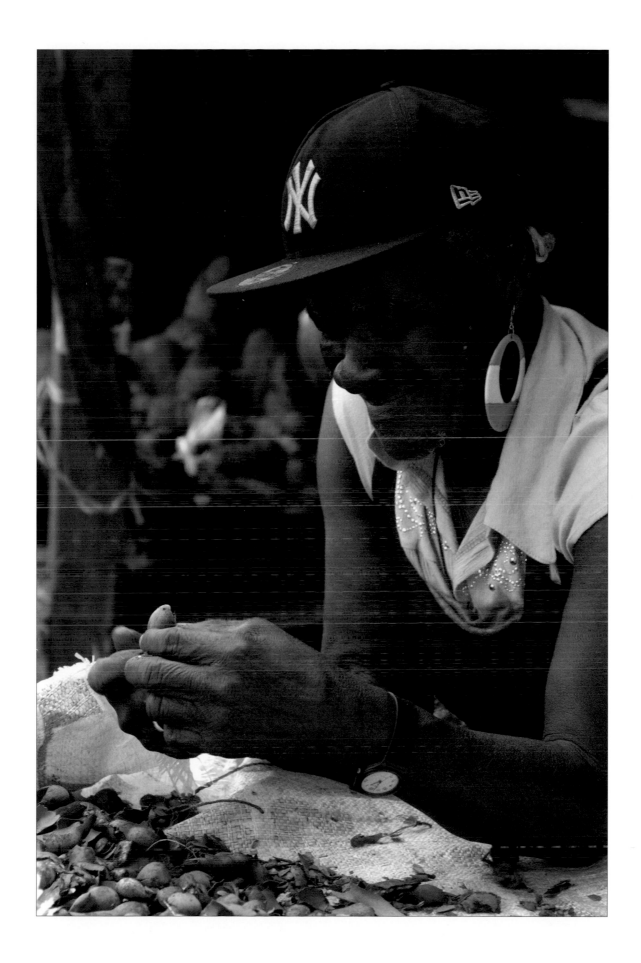

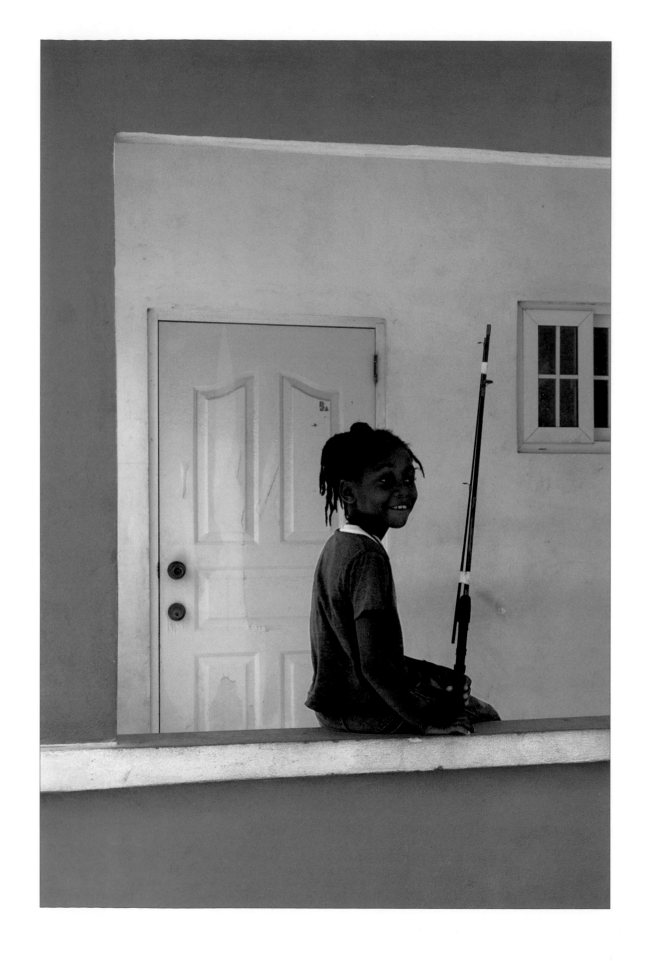

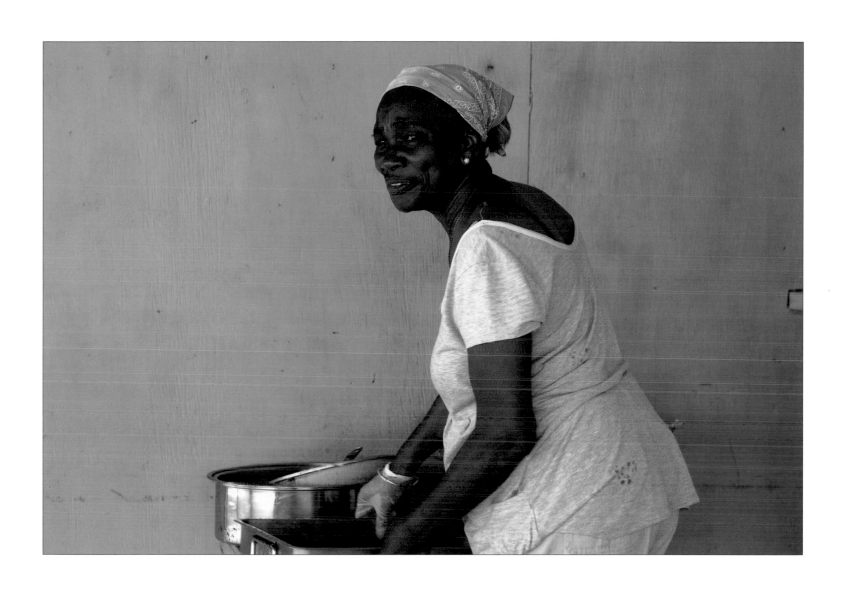

Vincy Colors

When, after a month in these islands, I landed in New York, I thought my sight had dimmed. The world seemed drained of color: the sky was grey, the buildings were grey, the trees, the people, and even the Yellow Cabs seemed pale.

Life in the islands had been bursts of color: the noonday sky as deep a blue as if tinged by the indigo night. The lush greens of the rainforest; the reds, yellows and oranges of jungle flowers; the hues of tropical fruit; the black of volcanic beaches and the pink of coral sand; the brilliant white of breaking waves and puffy clouds, the many-colored parrots, the spices in the markets, the freshly painted fish boats, the pastels of trellised houses; the vibrant dresses and bonnets of the ladies at Baptist service.

There is no halfway in these islands. You live life to the fullest, as ablaze as the colors. And at every blaze of color, you thank God for giving you sight.

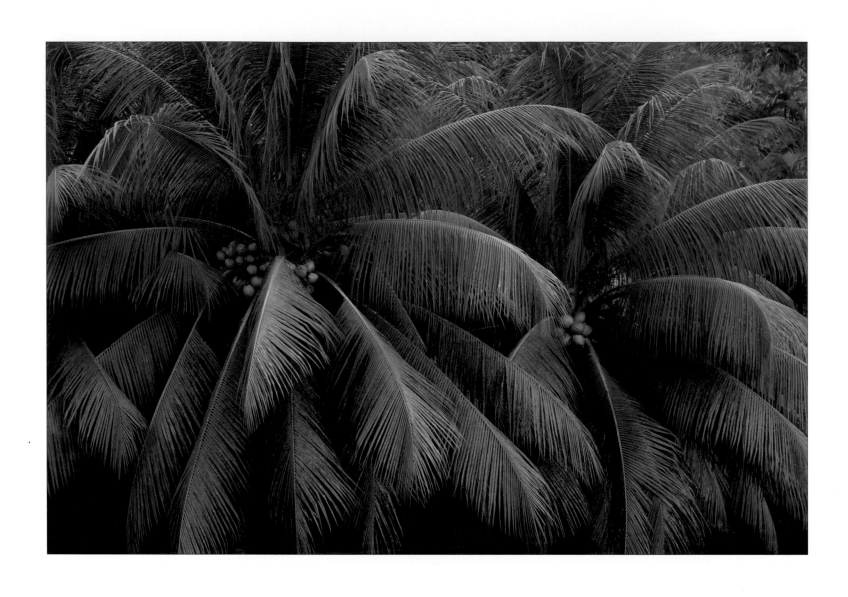

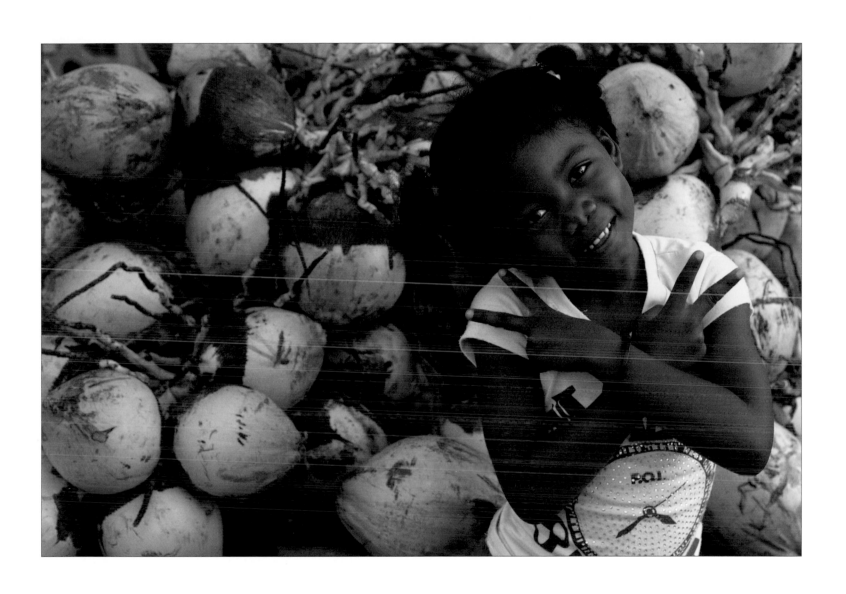

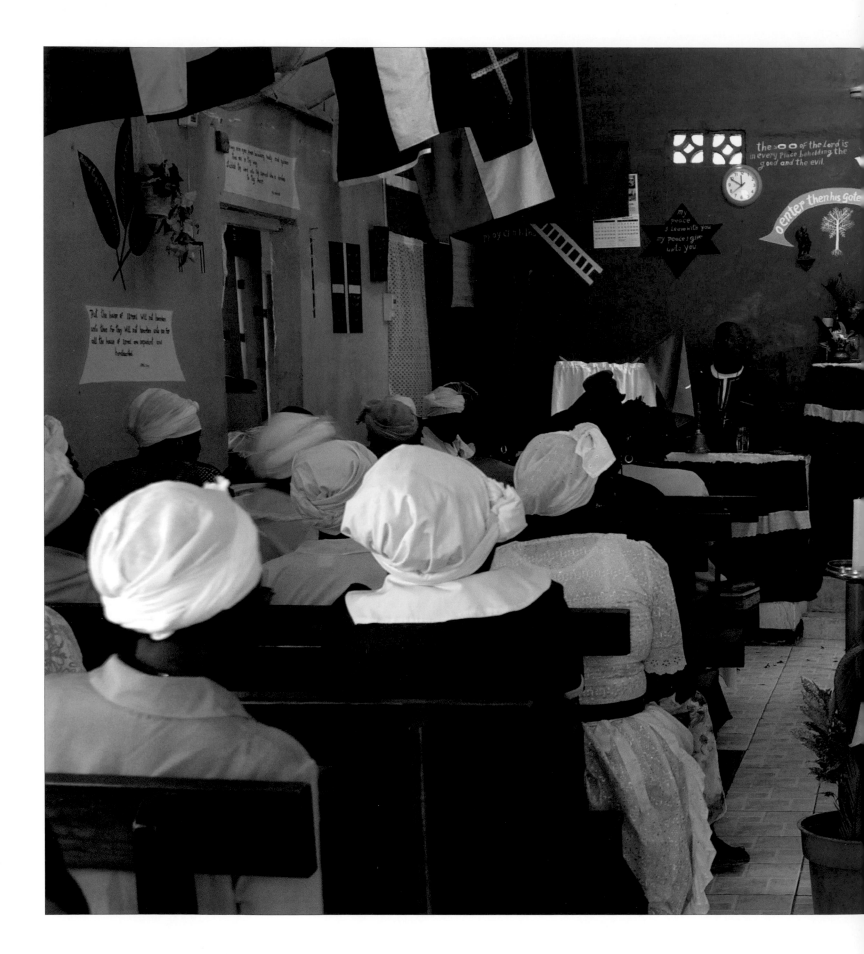

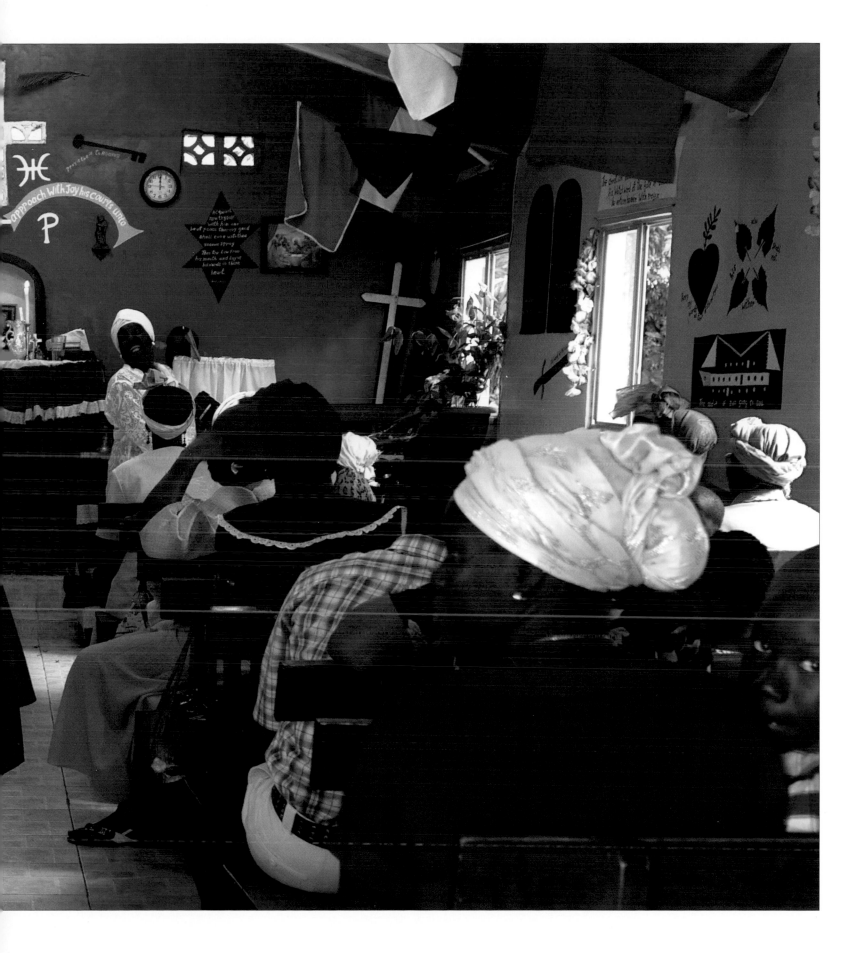

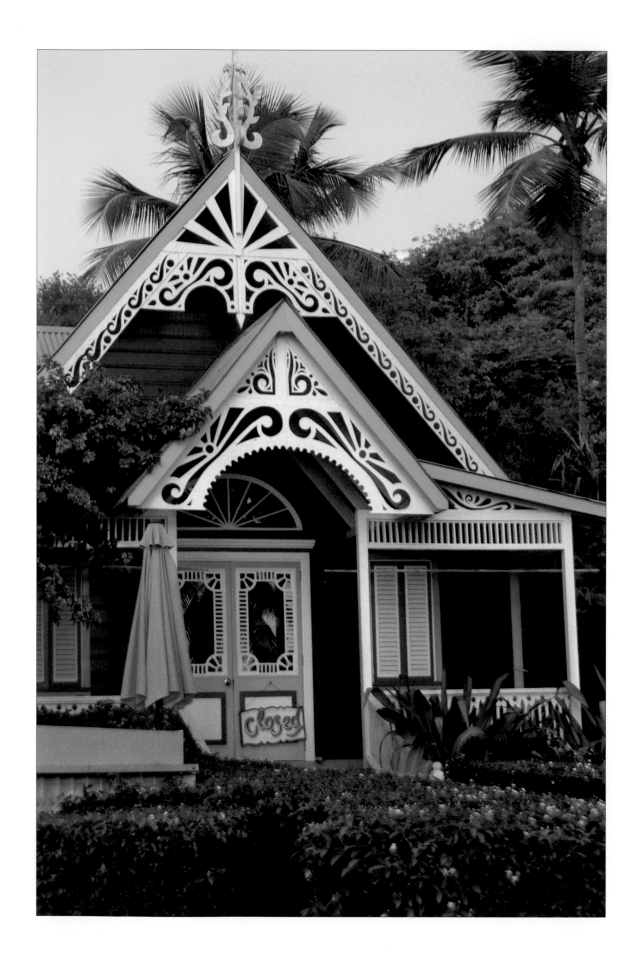

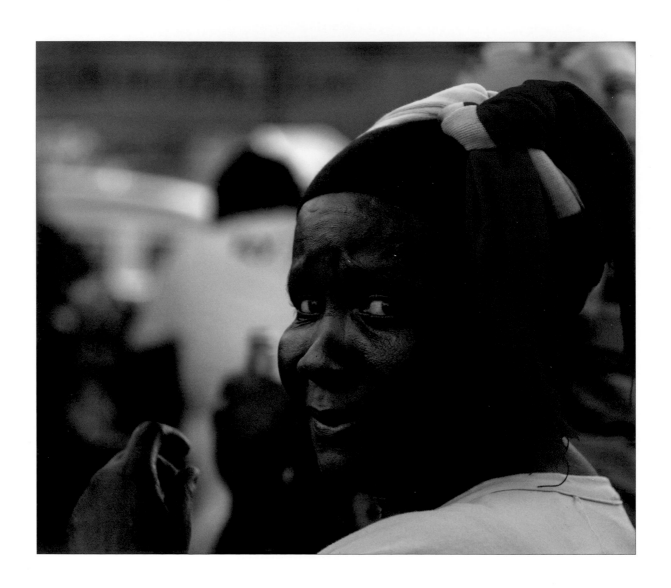

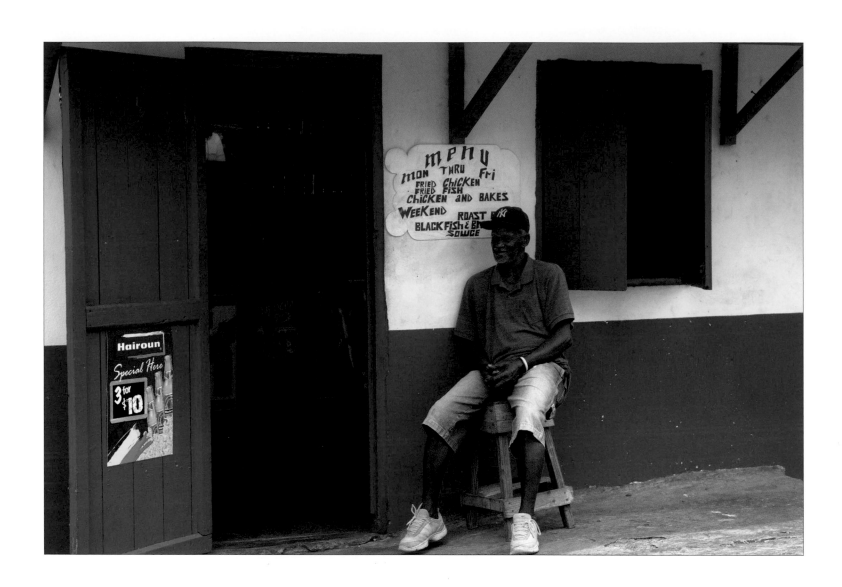

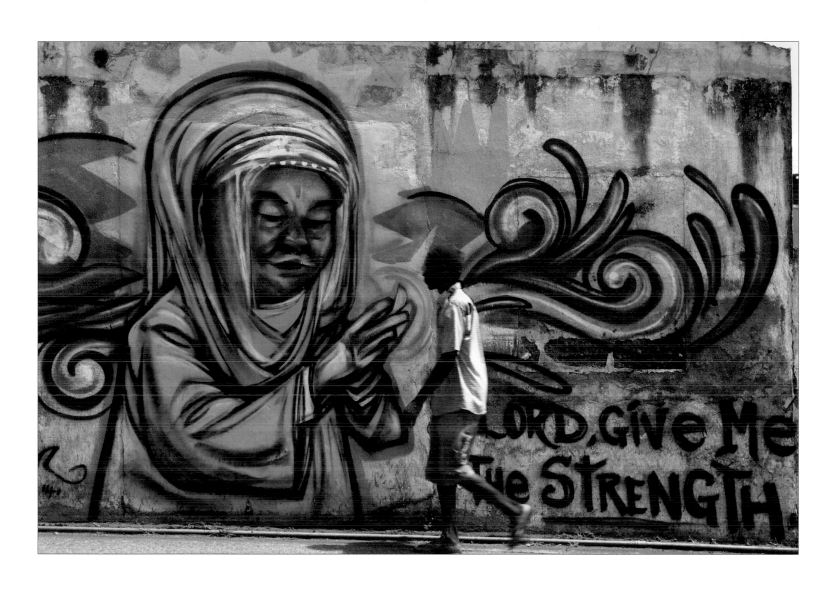

A Culinary Adventure

THESE ISLANDS ARE A GASTRONOMIC PARADISE. As any famous chef worth his girth will tell you, the most vital factor of unforgettable meals is unforgettable primary ingredients: the best meat, vegetables, fruits, and fish. In all those categories St. Vincent is hard to beat.

The volcanic soil is fertile and deep. The land is blessedly steep so not only does it drain well, but the plots are small and have to be worked by hand, mostly organically, tended with love and care and planted with what grows best. And what grows best is everything. Vegetables range from peppers, tomatoes, onions, corn, and callaloo (like spinach but much bigger and tastier) to root crops like sweet potatoes, cassava, dasheen, and yams. Fruit is boundless: papaya, banana, mango, coconut, pineapple, and of course to reflect the Vincentians' personality, passion fruit. Also grown are peanuts, sorrel, ginger, breadfruit, cinnamon, nutmeg, cloves, cocoa, and coffee. And since the trip from field to market is always less than 37 miles, everything arrives at your table perfectly mature, full of aromas, full of unforgettable flavors.

The fish? You want it, they have it: everything from tuna and snapper to conch and lobster.

Meat? The best. Everything is free-range—cows, chickens, sheep, and goats—roaming fields, woods, and roadside. The most tender and tasty steak of my life I ate on St. Vincent.

The daily street markets are awash with small stalls run by the farmers or their families. The vast fish market teems with daily catches at prices that make you want to load up a van. On the smaller islands, fish can be bought direct from the fishermen who sell from their small sturdy crafts pulled up on shore. For those who can't go to market, a truck comes loaded with fish packed in ice, a scale dangling on the open deck of the pickup truck, the fishmonger blowing a conch shell, its loud bucolic sound filling the air.

The cooked food at stalls or by the roadside, or in small restaurants is often prepared while you wait. I mean only after you place the order does the garlic get peeled, the chives sliced, the red peppers diced. Now that is fresh.

Buon appetito!

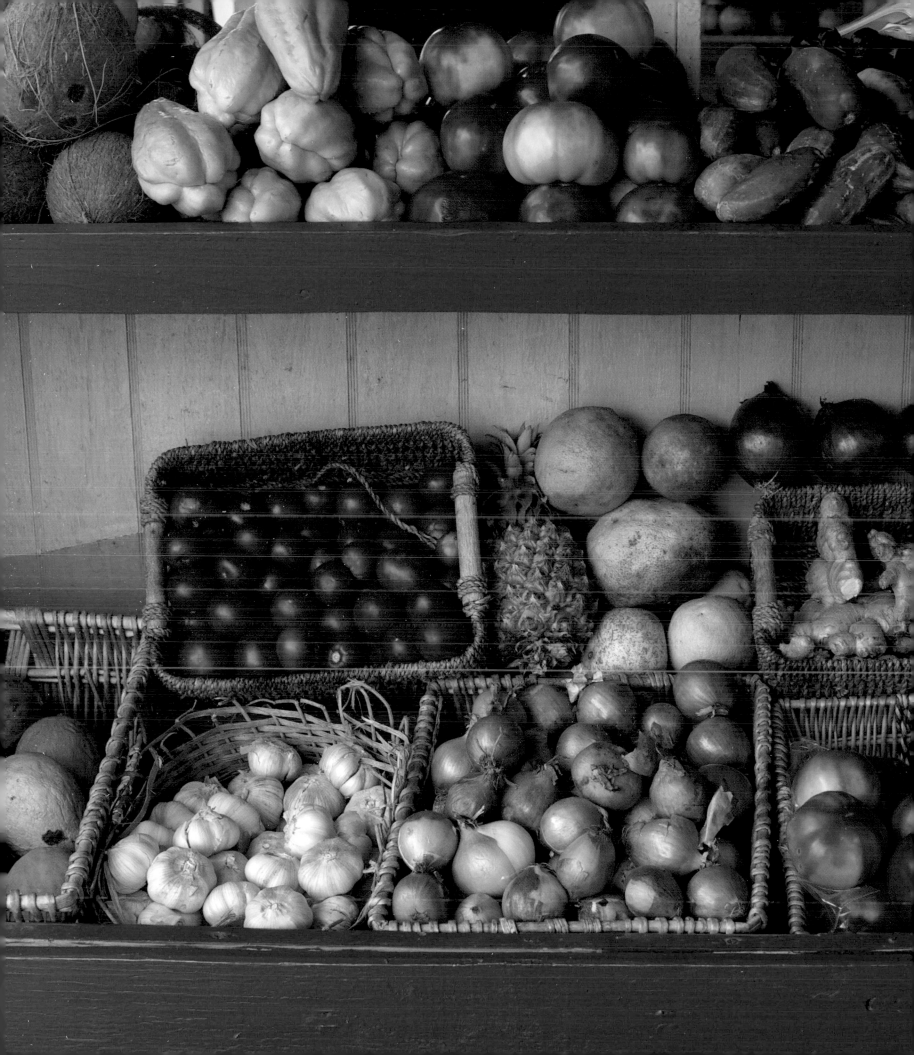

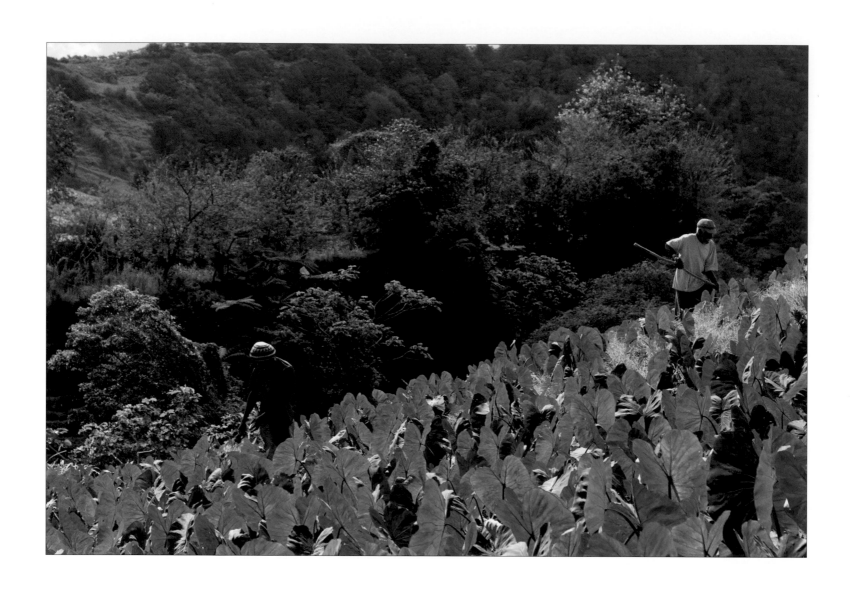

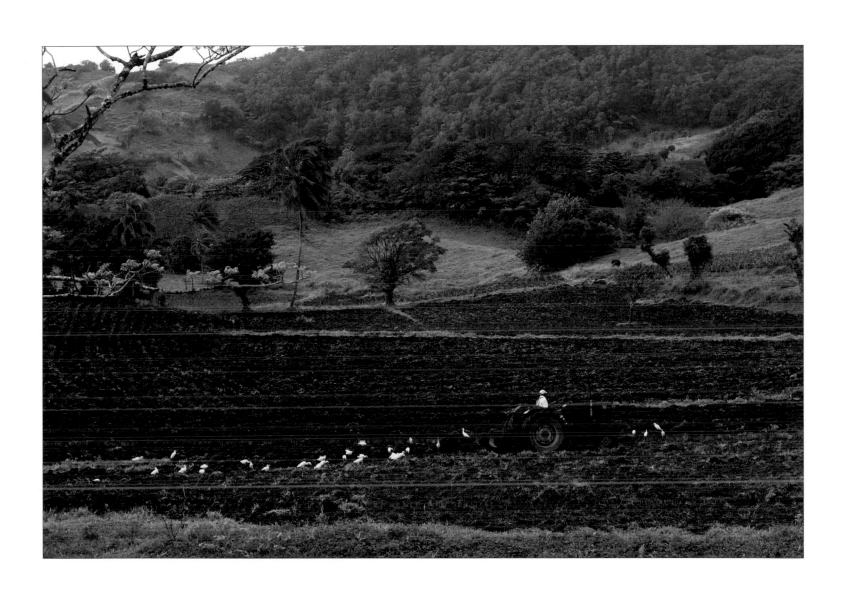

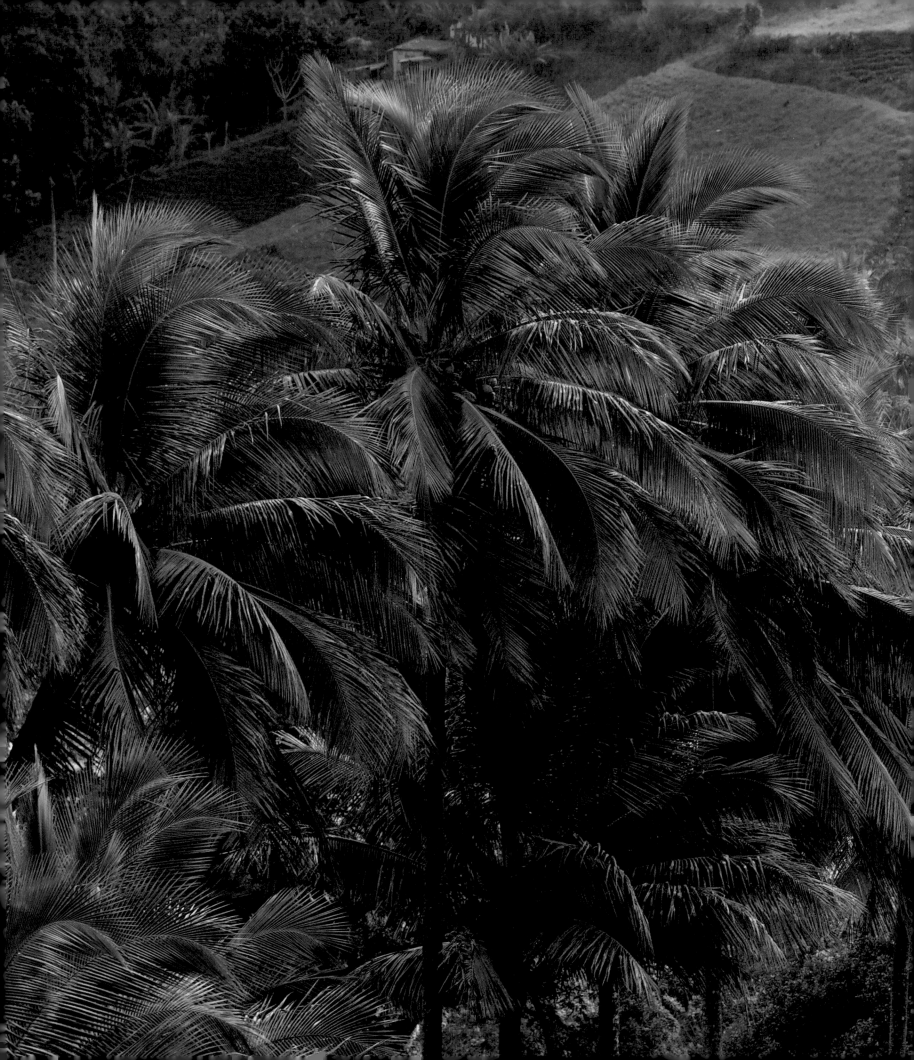

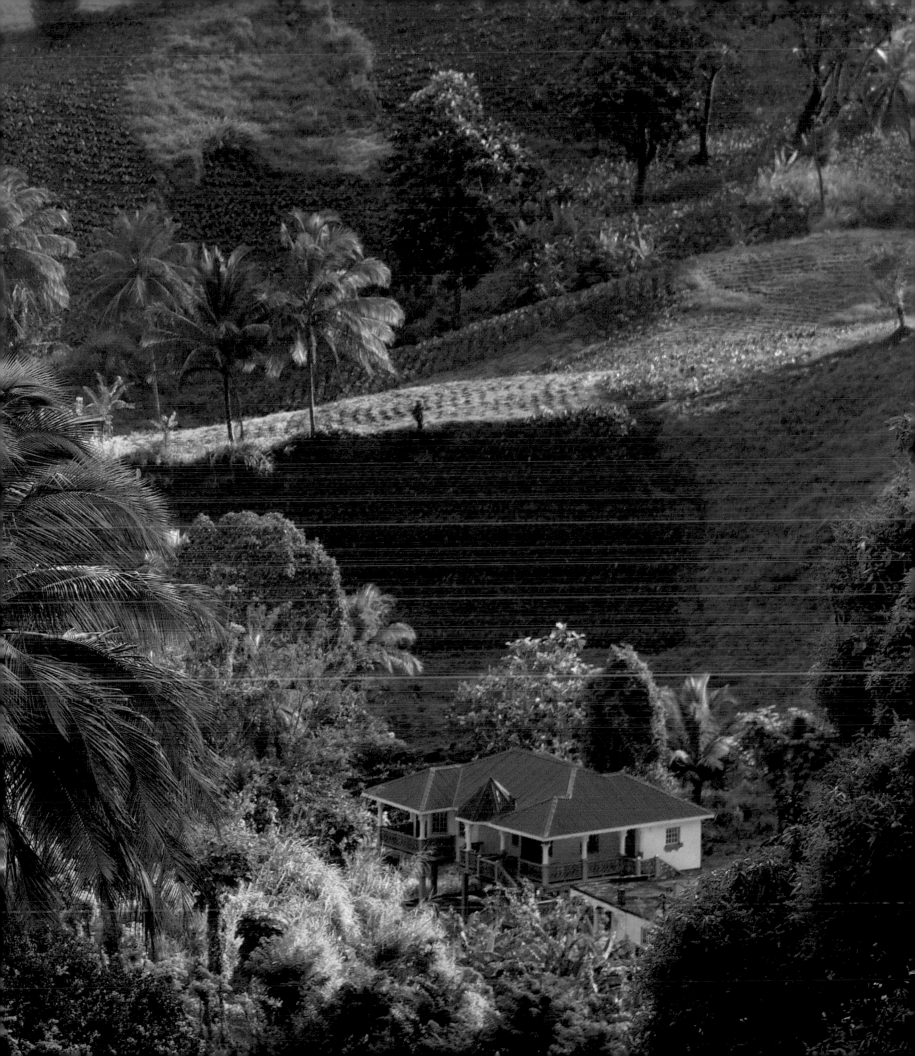

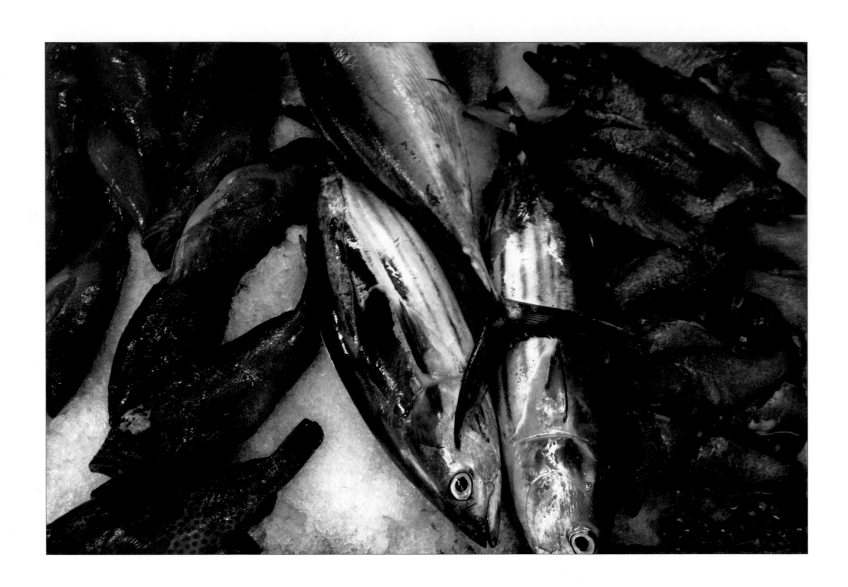

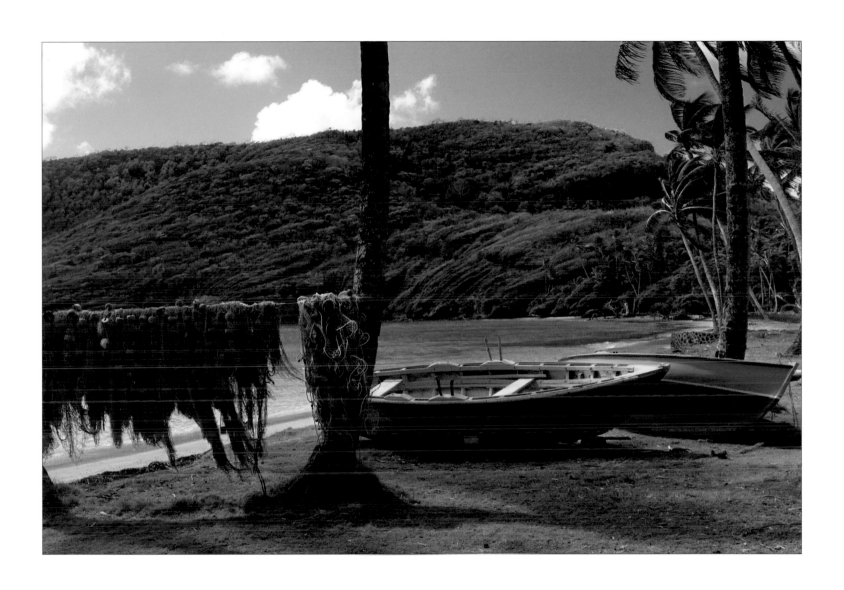

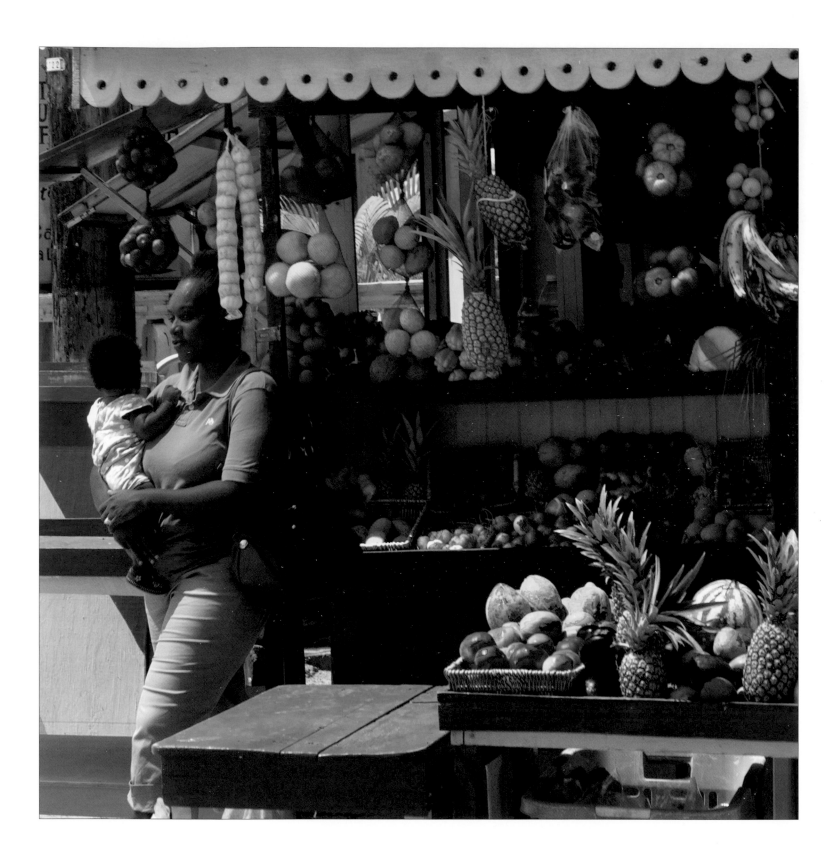

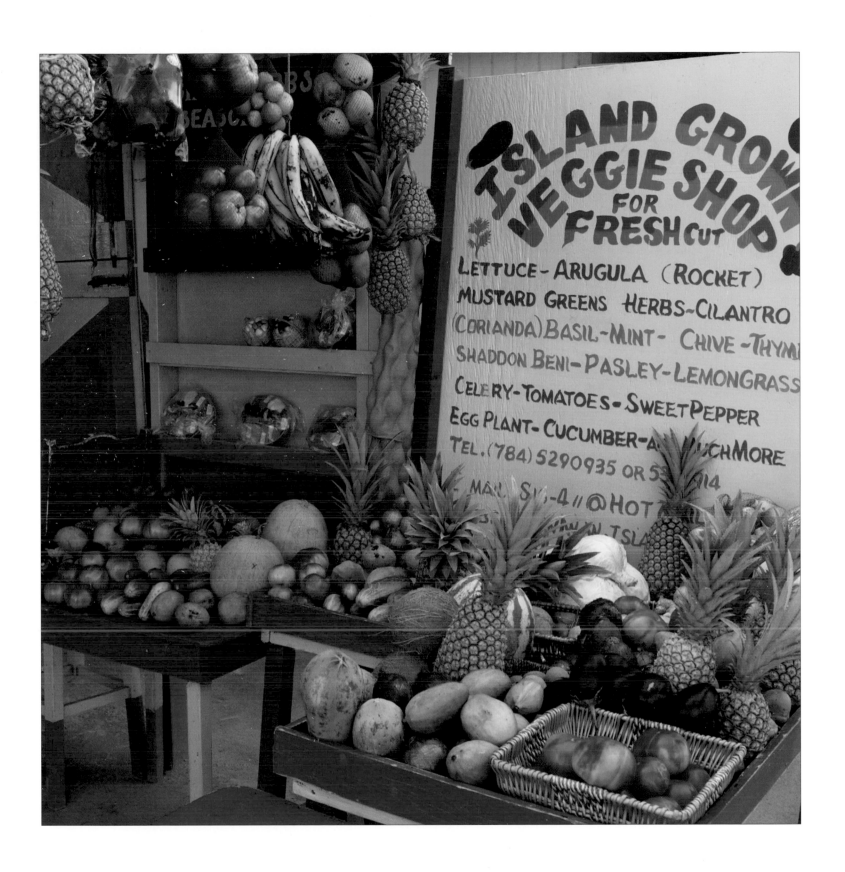

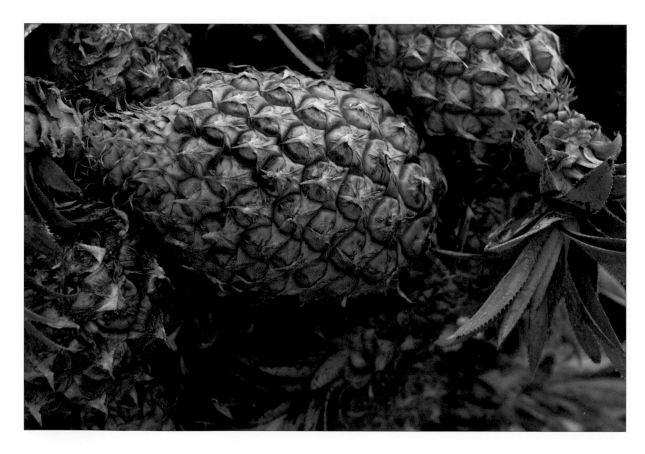

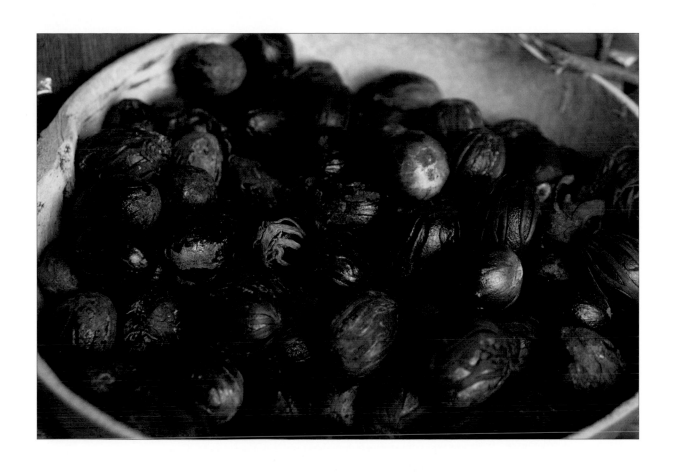

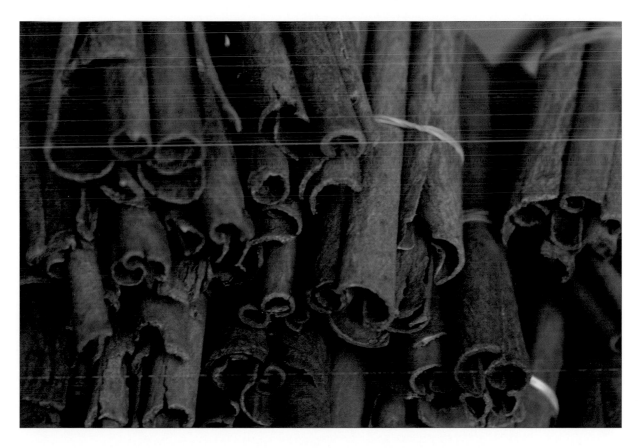

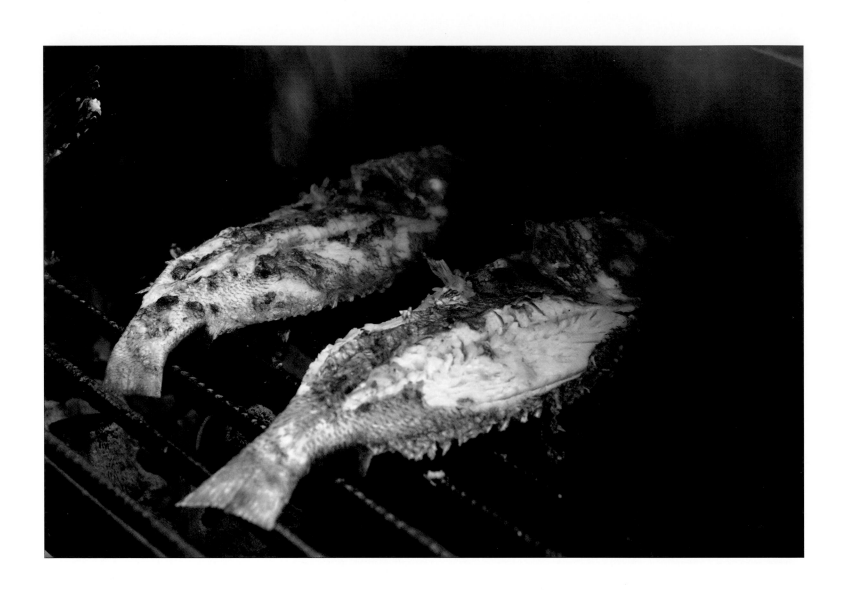

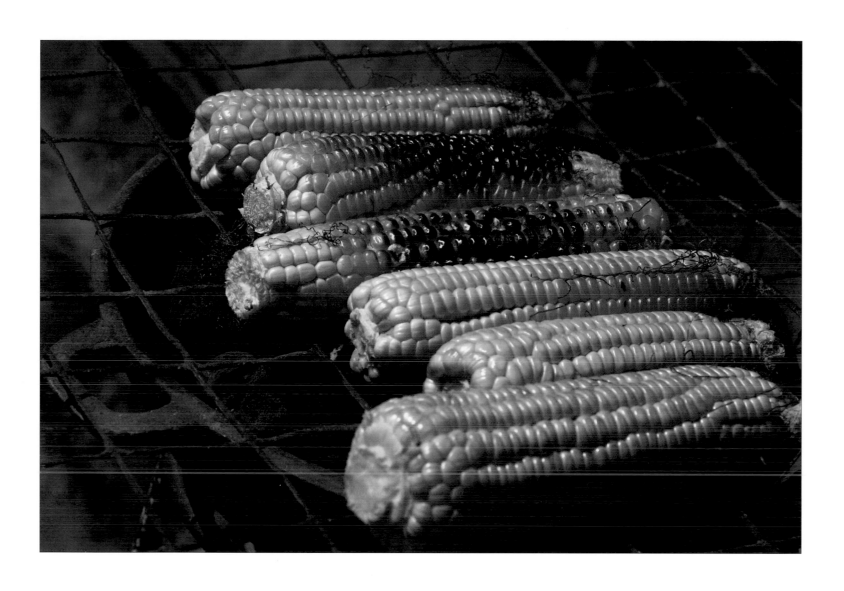

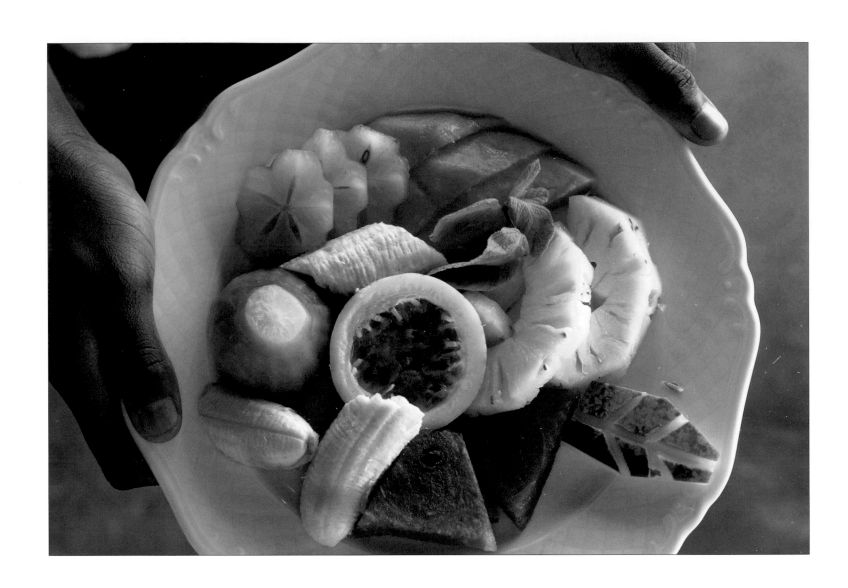

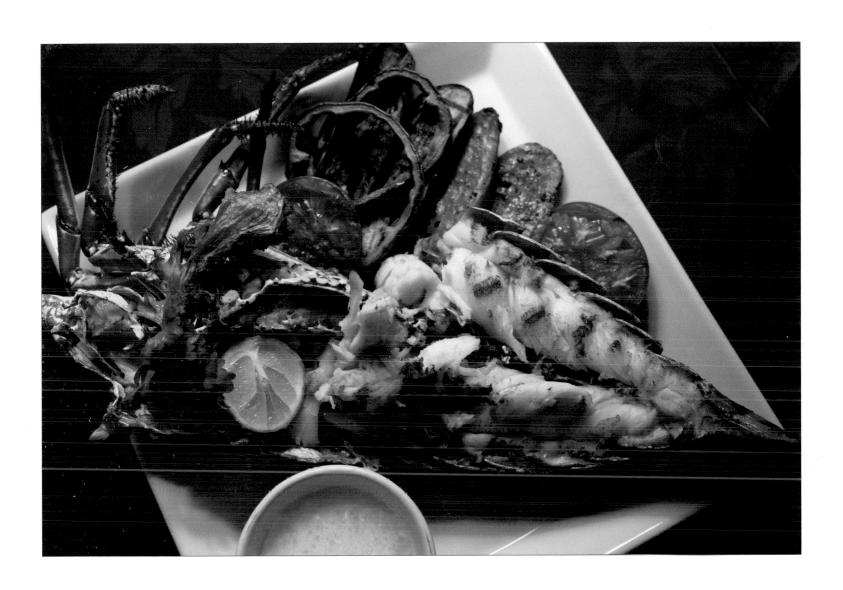

LIMING

ANDREW IS A GENTLE, SOFT-SPOKEN MAN. My age. He knows every beautiful corner of St. Vincent as well as every herb, fruit, nut, spice, plant, flower, and weed in the fields or by the roadside. He was my guide on "The Mainland" for two weeks. He told me that in the old days liming meant guys hanging out, courting girls. But that has changed: now liming is everybody hanging out with everybody. It can mean simply sitting on a stoop, or a bench, in a rum shop, or on the seashore, or just by the roadside and talking to whoever happens to come by. Exchanging stories, gossip, jokes. Being human.

Universal liming in a major way starts Friday and Saturday afternoons. Then dances effortlessly into night. It's in Heritage Square in Kingstown, the harbor front park on Bequia, the main street of Union Island, on the numerous three-tiered bleacher-like benches built just for this purpose on Canouan, or beaches or church steps in every town. You need only three things for liming: something to drink, music, and people. The inevitable outcome is dancing.

Saying that the people of these islands love to dance is like saying that fish love water. They dance while cooking dinner or loading carts. They sway and bob while hoeing fields or waiting tables. I've even seen people dance sitting down.

Kingstown's Heritage Square speaks of neither a square nor heritage except maybe for the short bridge over the creek that borders its eastern side, but it is as lively and fun a place as you can imagine during liming. It seems the whole island is there—babies in strollers, in arms or on shoulders; kids on steps, on bridge railings on lampposts; teenagers everywhere, the young everywhere and the old too, sitting, standing, mingling, chatting. Dozens of impromptu bars pop up among the crowd, on tables, or benches, all full of Hairoun beer, fruit juices, juicy topics, and rum. Then at no particular time the music starts. And if you think you've seen dancing, I tell you brothers and sisters, you ain't seen nothing yet. Dancing in SVG makes Miley Cyrus seem stiff as a board, and duller than a concrete block.

I asked Andrew how recently the dancing had become so sensuous, so wild. He laughed. Then he waved a hand over his shoulder, back to a time before his three wives and six children, before the first airport was built in the islands, before the first radio station's music came across the sea.

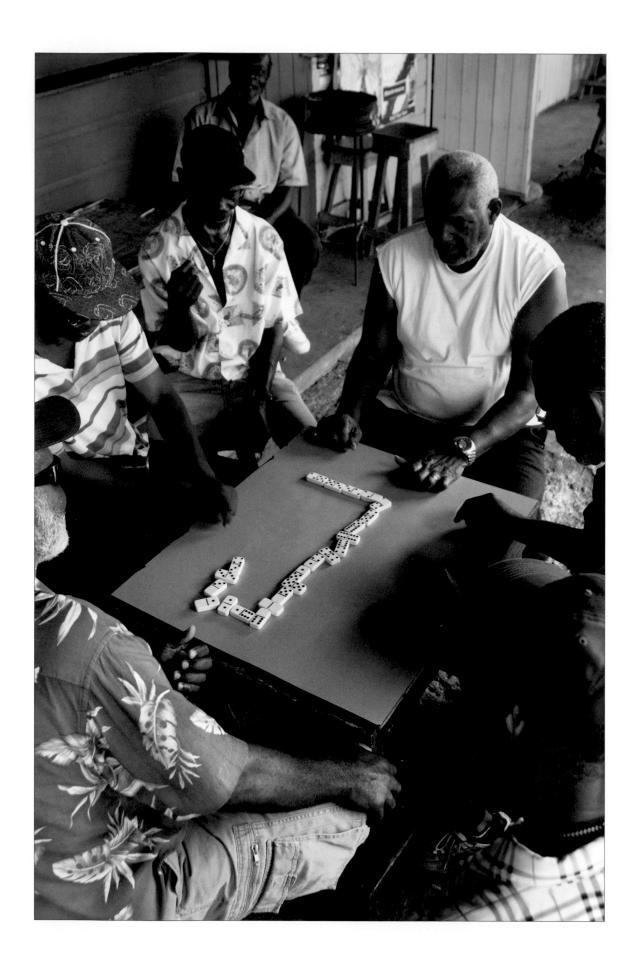

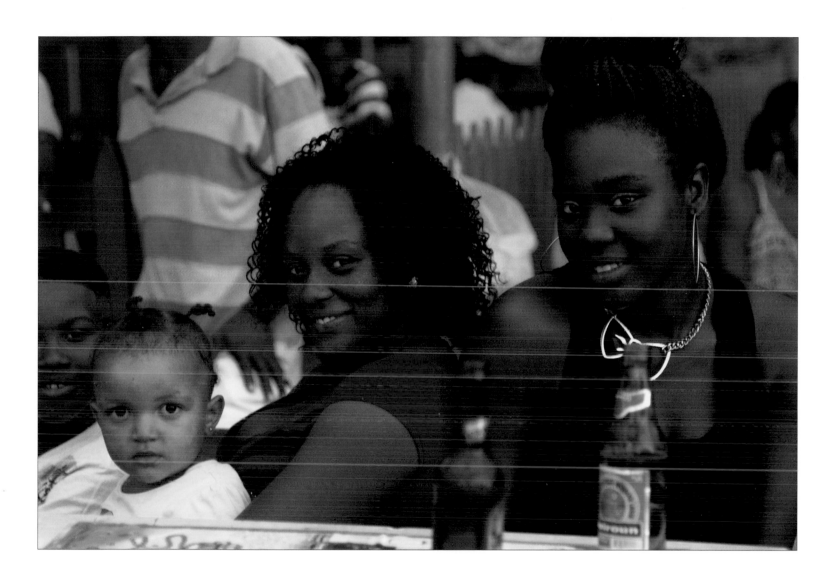

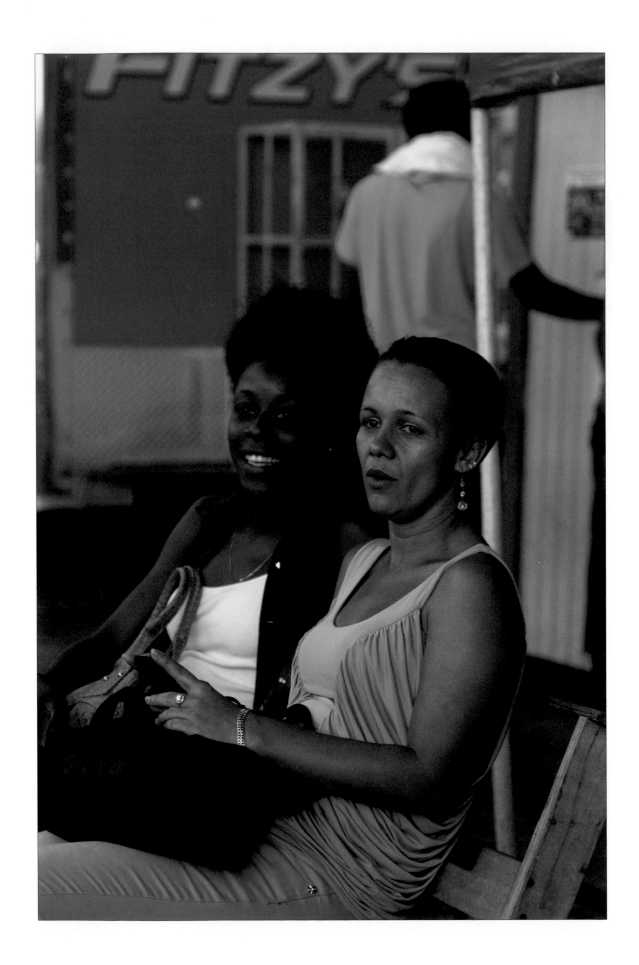

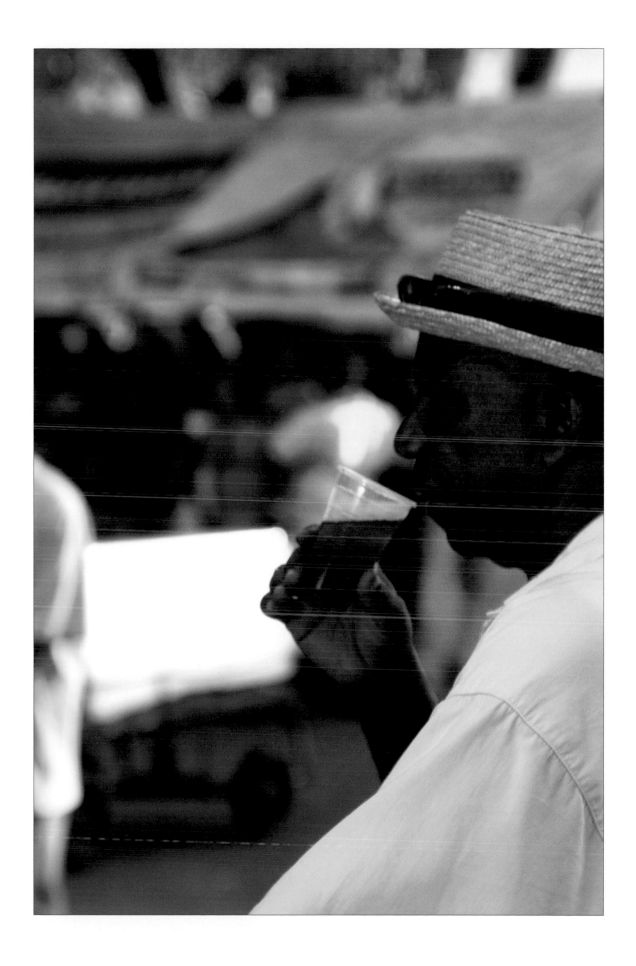

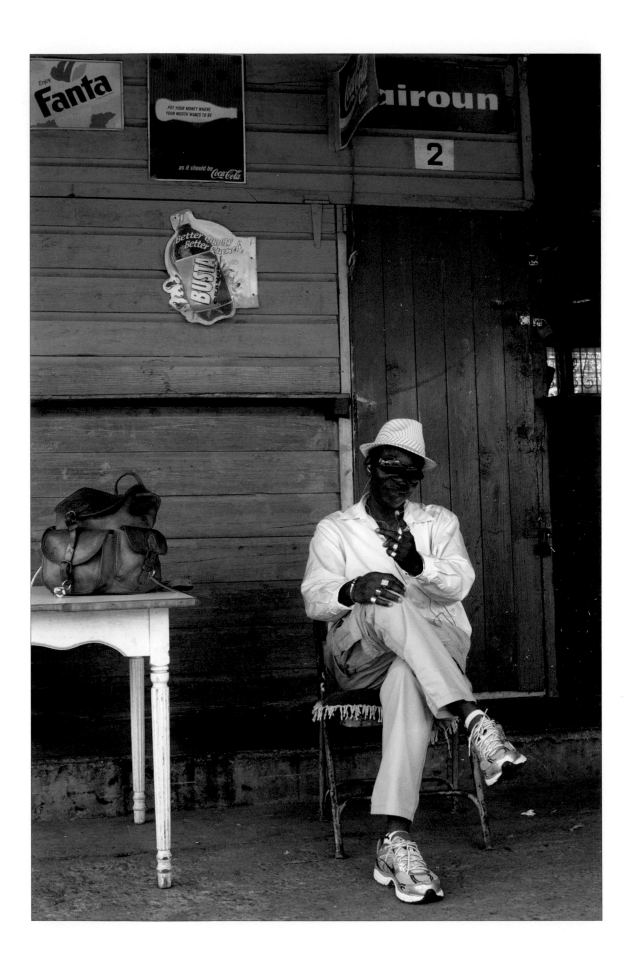

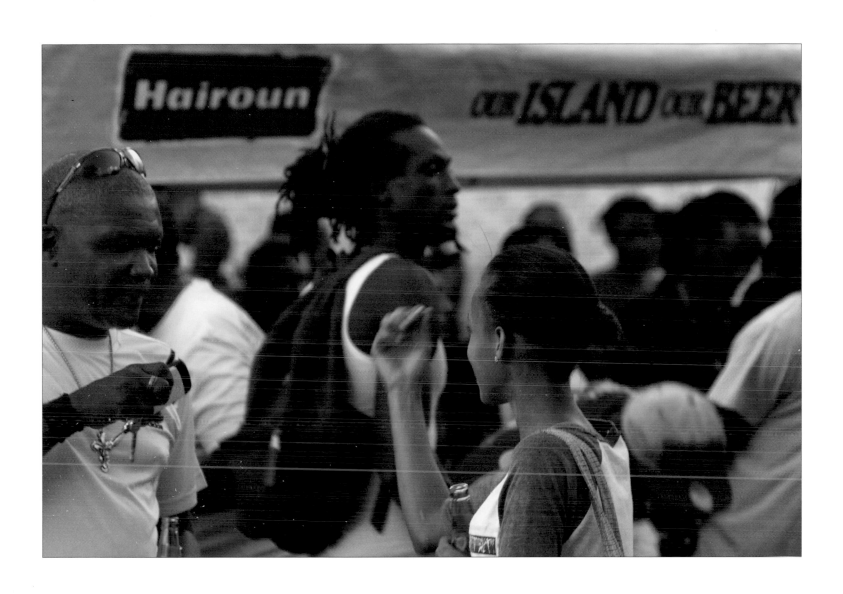

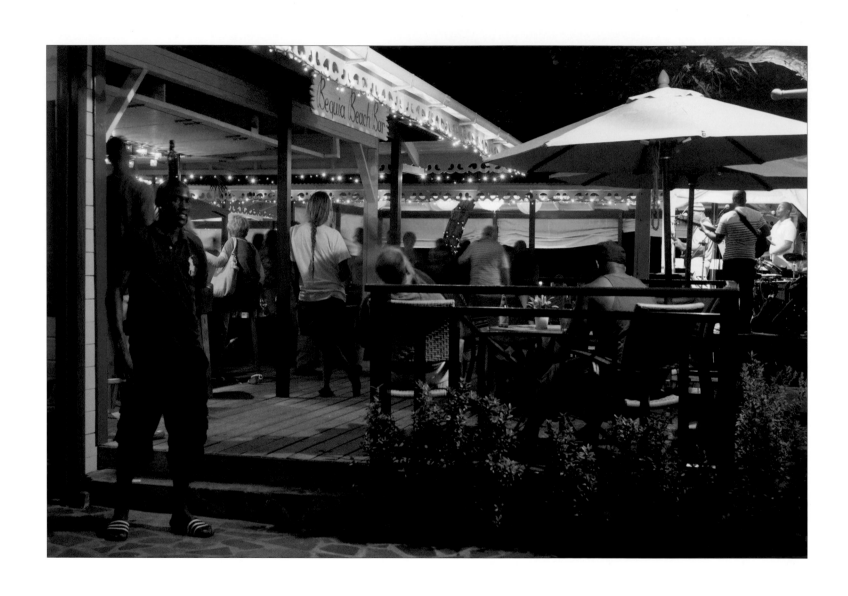

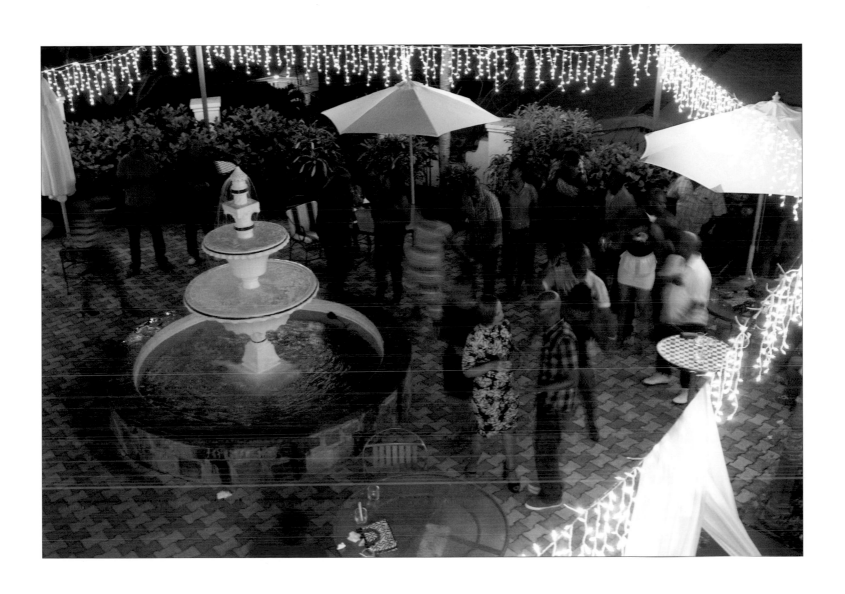

Between Two Seas

I never tired in these islands. There was much to see, much to do, and much of both was related to the seas.

The shores of the islands are two different worlds. The Atlantic side with its stormy waters feels fresh, majestic, full of waves crashing at the foot of bluffs or spewing into foam on long beaches. The Caribbean side is tranquil; the harbors are so calm, fish-boats sit on the sands.

On the Atlantic side, I could sit for hours on a rocky point watching the waves boil around me; on the Caribbean side, I could doze on the beach, or float in the sea, or snorkel, or sail on a long and pleasant reach with the wind on the beam, riding the swells and waves.

Or I could sit on the dock of a bay and watch sailboats come to rest at anchor, come from all over the world to see the marvels of these seas.

Then there are the villages of the fishermen. They're made for nomads. For the fishermen of these islands move from island to island, following the runs of fish, which vary with the seasons, with the currents, with the moon.

So each island has a well-appointed little town where the fishermen from the other islands can stop in for whatever length of time, where they can cook, eat and sleep, clean and store their catch in big cooling containers, mend nets and boats, and of course socialize.

I stopped beside two fishermen late one afternoon. They were sitting under a palm-frond roof with a pile of seaweed on the table between them. They were painstakingly scraping the sand off the weeds, one leaf at a time. I asked them what that was. "Sea moss," one of them said. "You cook it?" I asked. "You dry it," one answered, "then you grind it into a powder and stir it into milk."

"Tastes good?"

"Tastes awful. But . . ." and he grinned and raised a stiff forearm, "I guarantee you won't sleep on your stomach for three days."

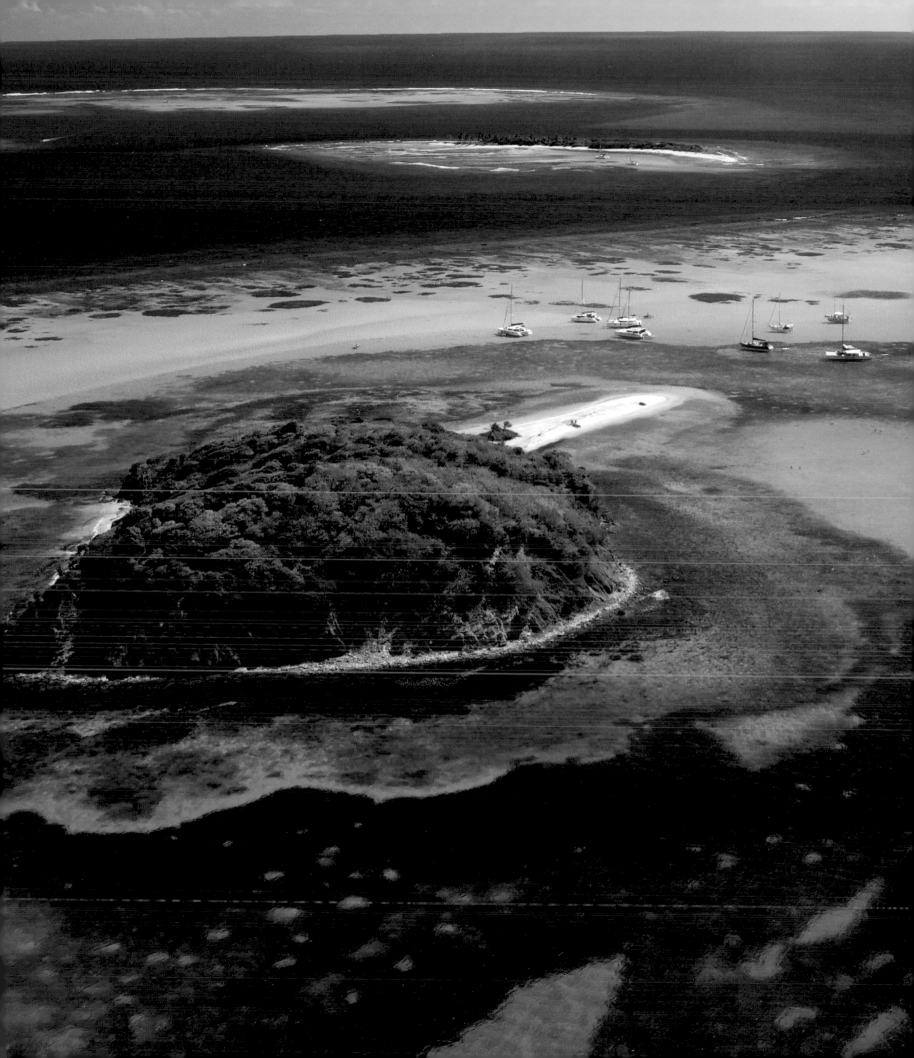

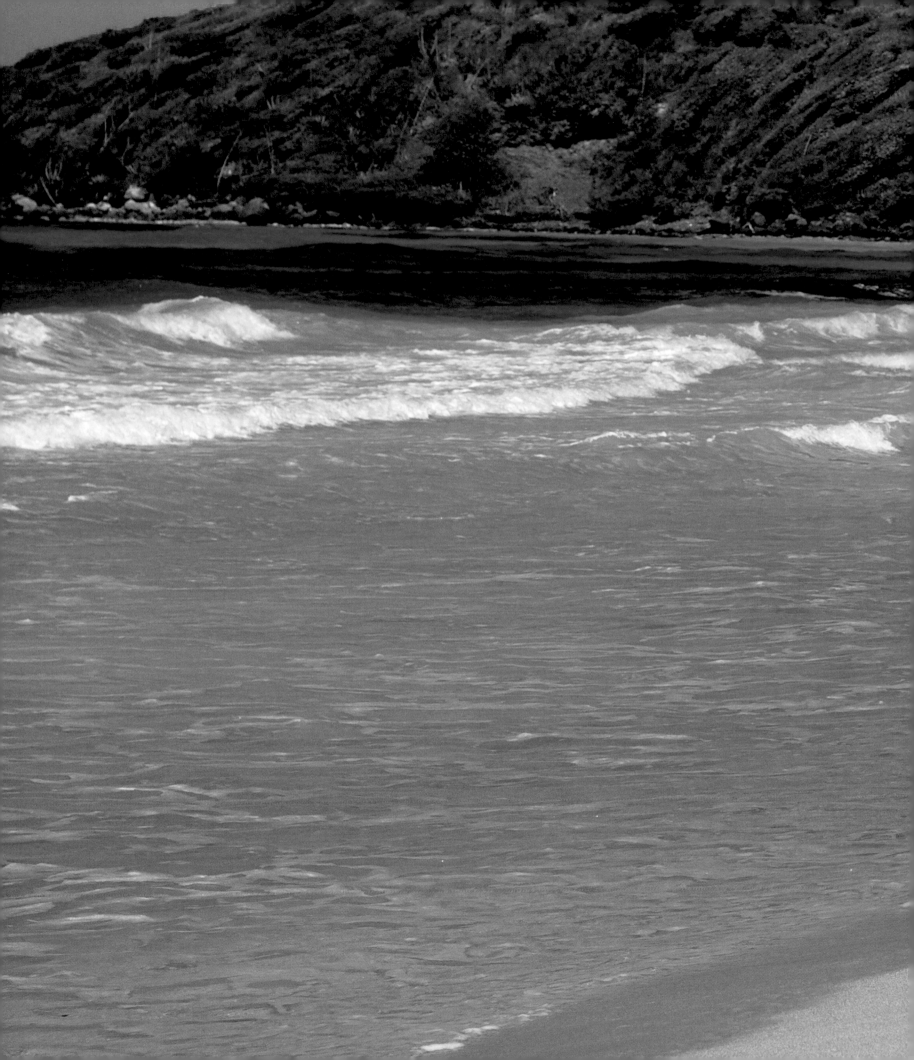

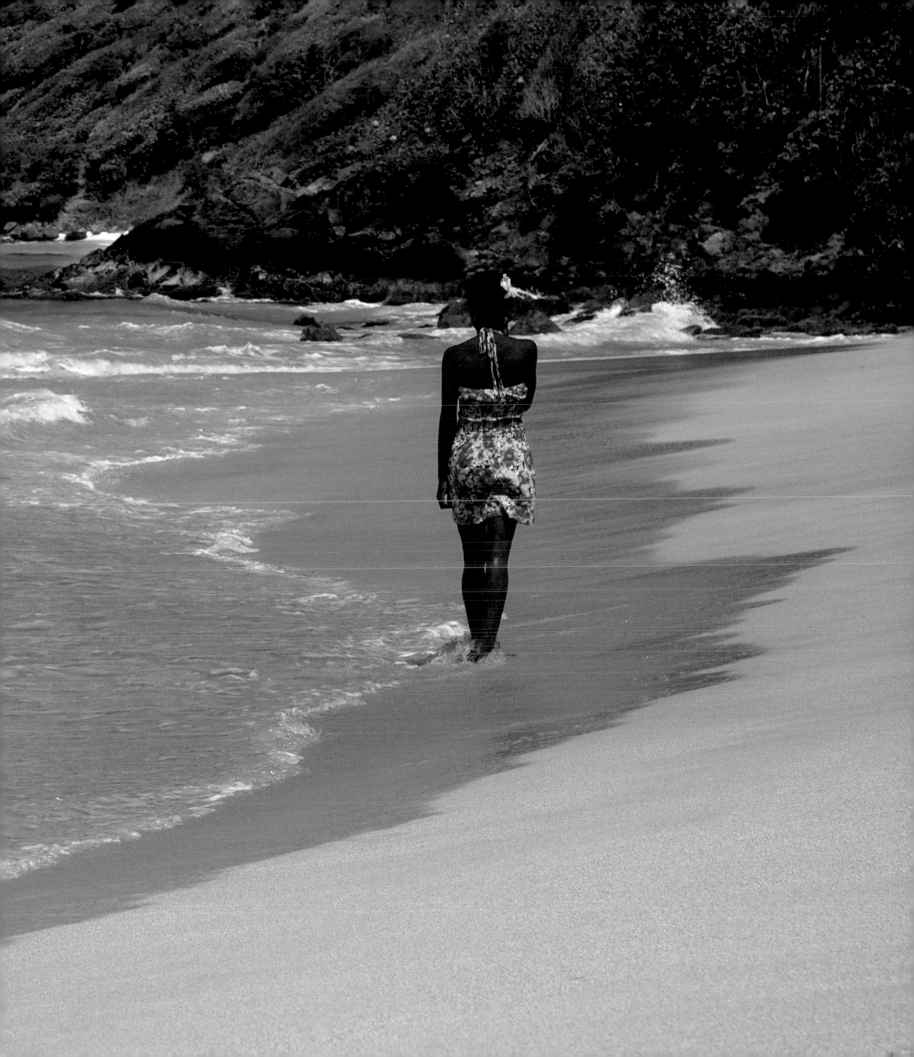

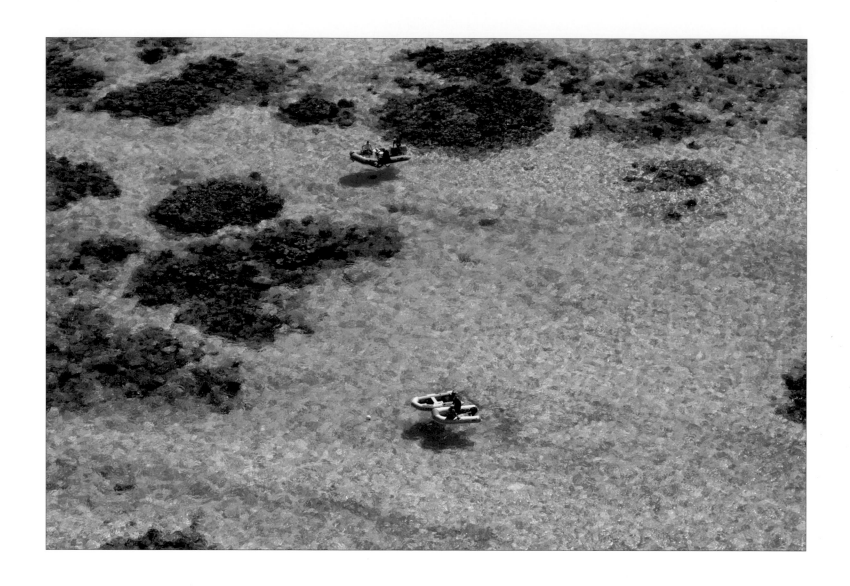

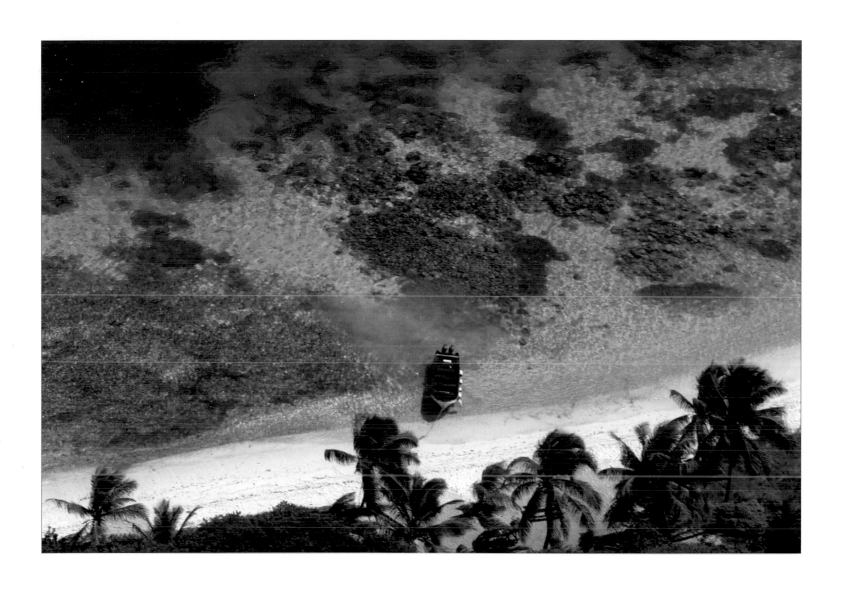

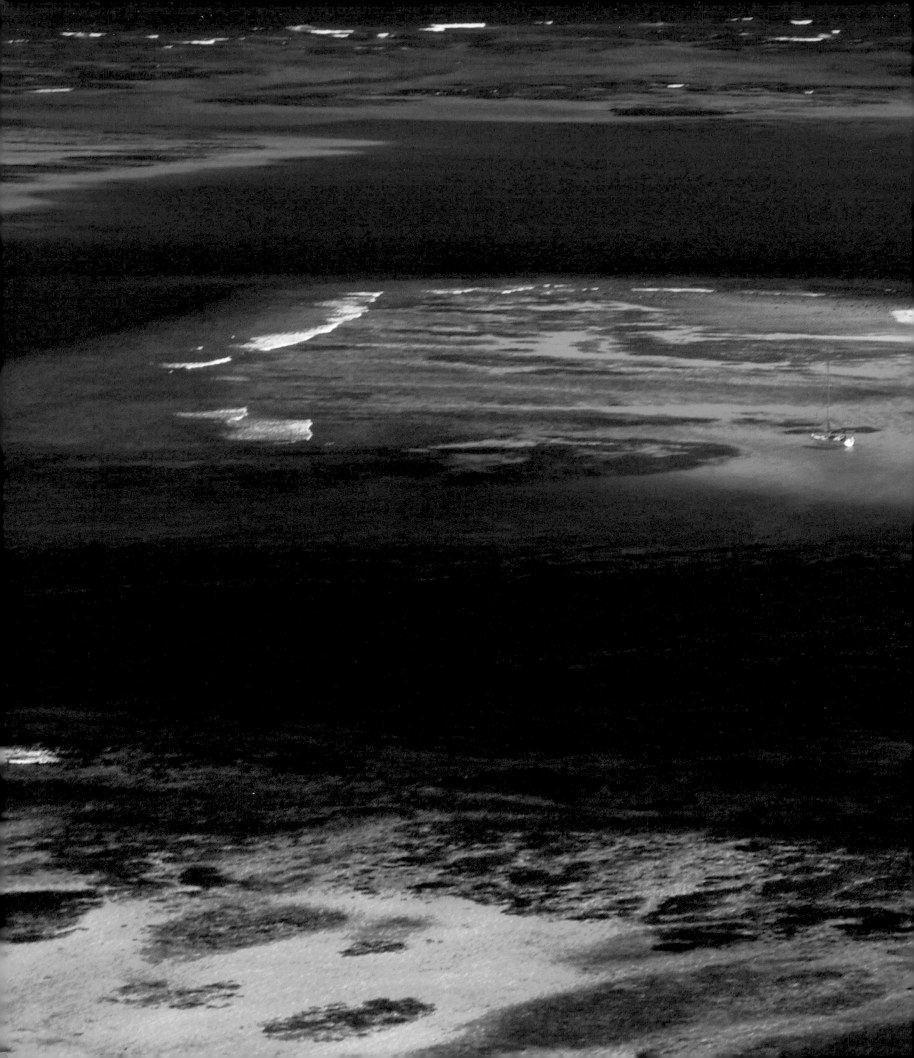

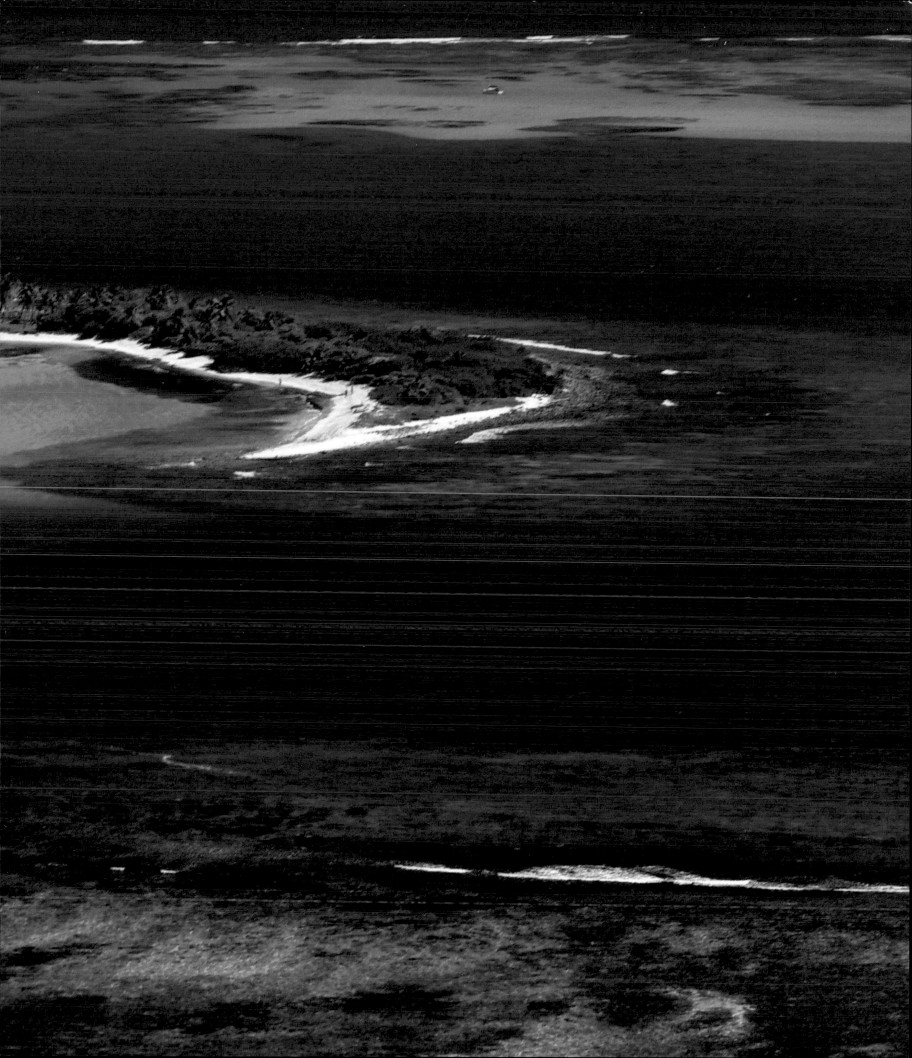

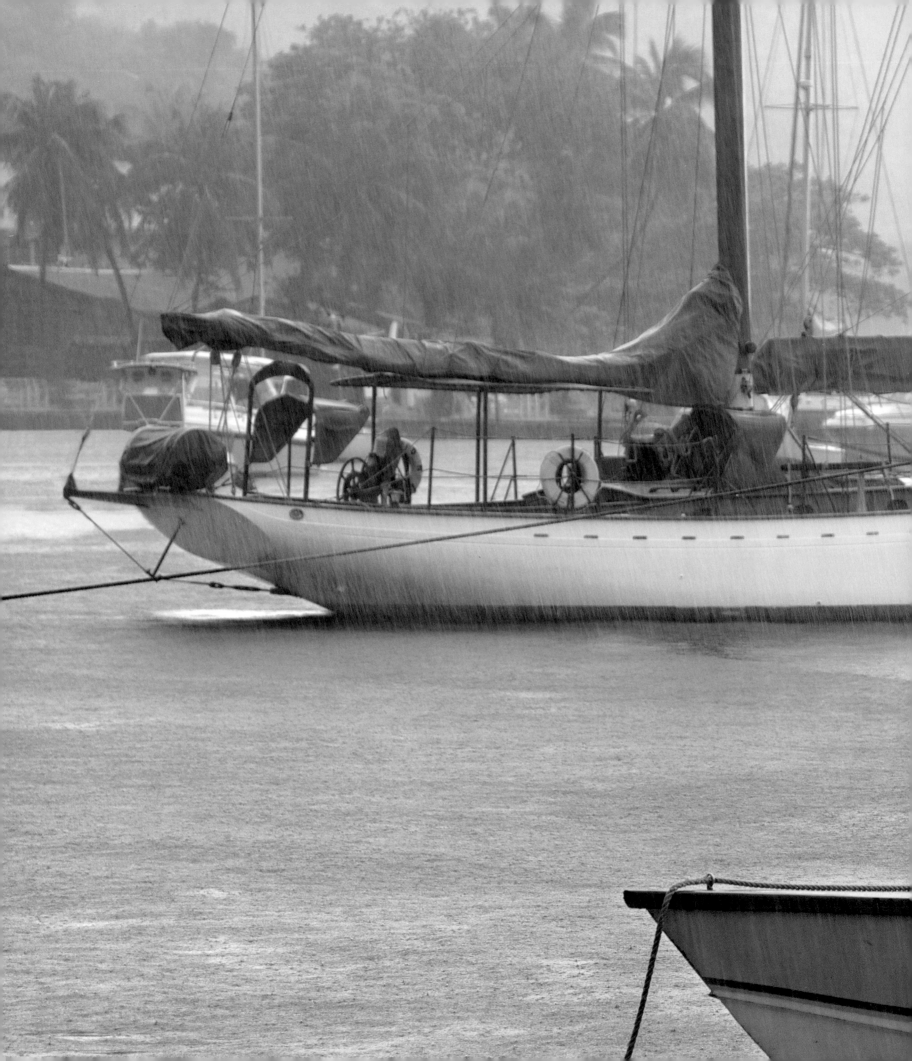

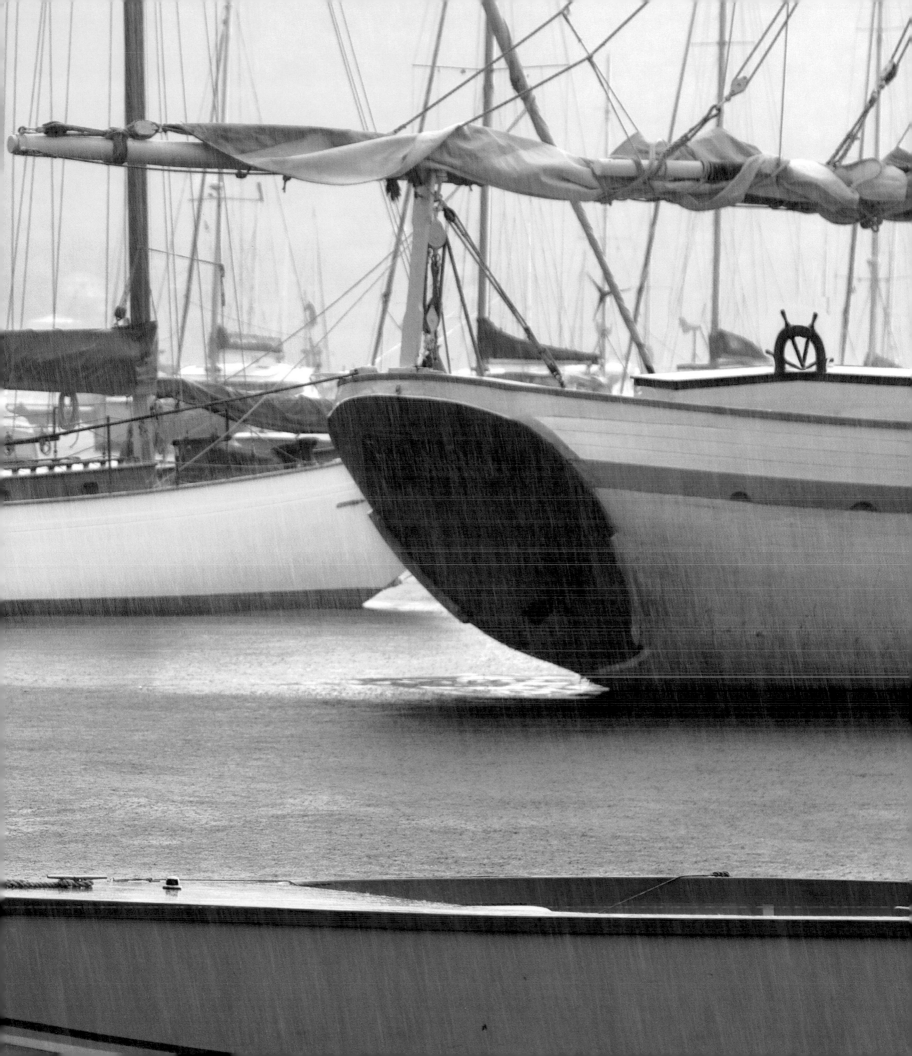

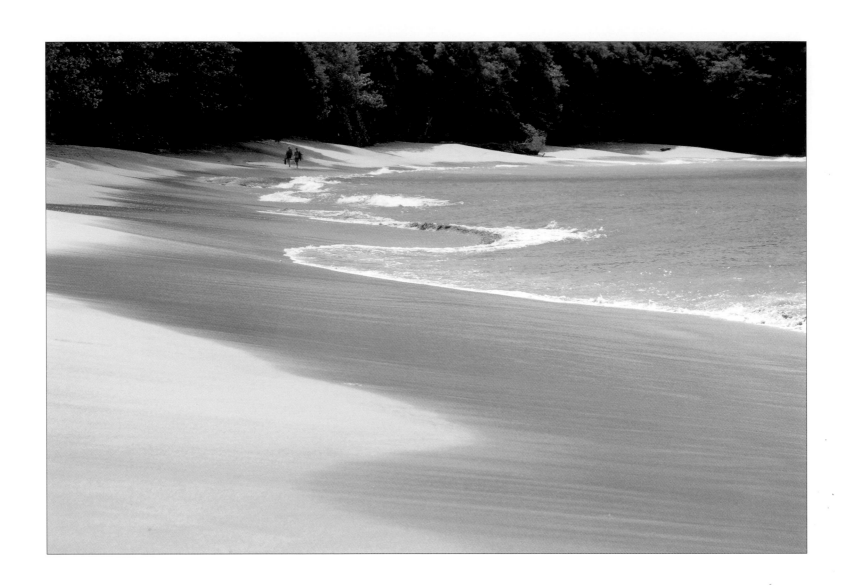

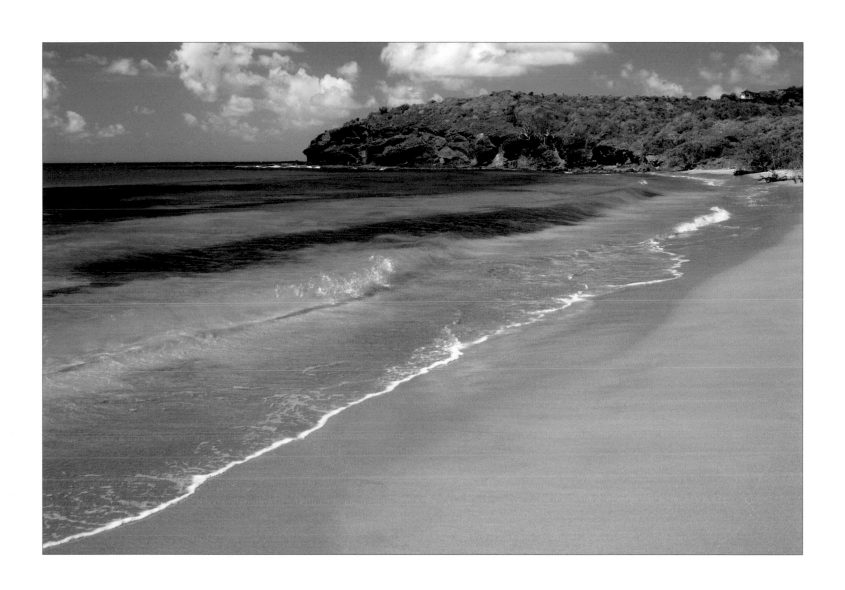

HIDEAWAYS

THE RUGGED HILLY TERRAIN has helped these islands remain lost in time. There was simply no flat space to build airport runways. Even when large scale, earthmoving began, the results were modest, accommodating only small planes from the nearby islands.

With the small planes bringing few tourists, the places to stay also remained small—to a human, even romantic scale. The hills give almost every place a long view, the rugged terrain guarantees solitude, and with their quiet grounds and deserted beaches where the only sounds are the birds, the wind, and the waves breaking on the sand, I can honestly call most of them "hideaways."

For me the ultimate hideaway has always been the sea; a good sturdy sailboat on the sea. Sailing lets you live life to the fullest: your body, your brain, and your soul all intensely alive. In the Grenadines you can have a new life every day. No island is more than a three-hour sail from another, the trade winds blow at a steady 15 knots, and the harbors, while often small, yield either utter solitude or good restaurants and bars. And to a sailor all that makes for Paradise.

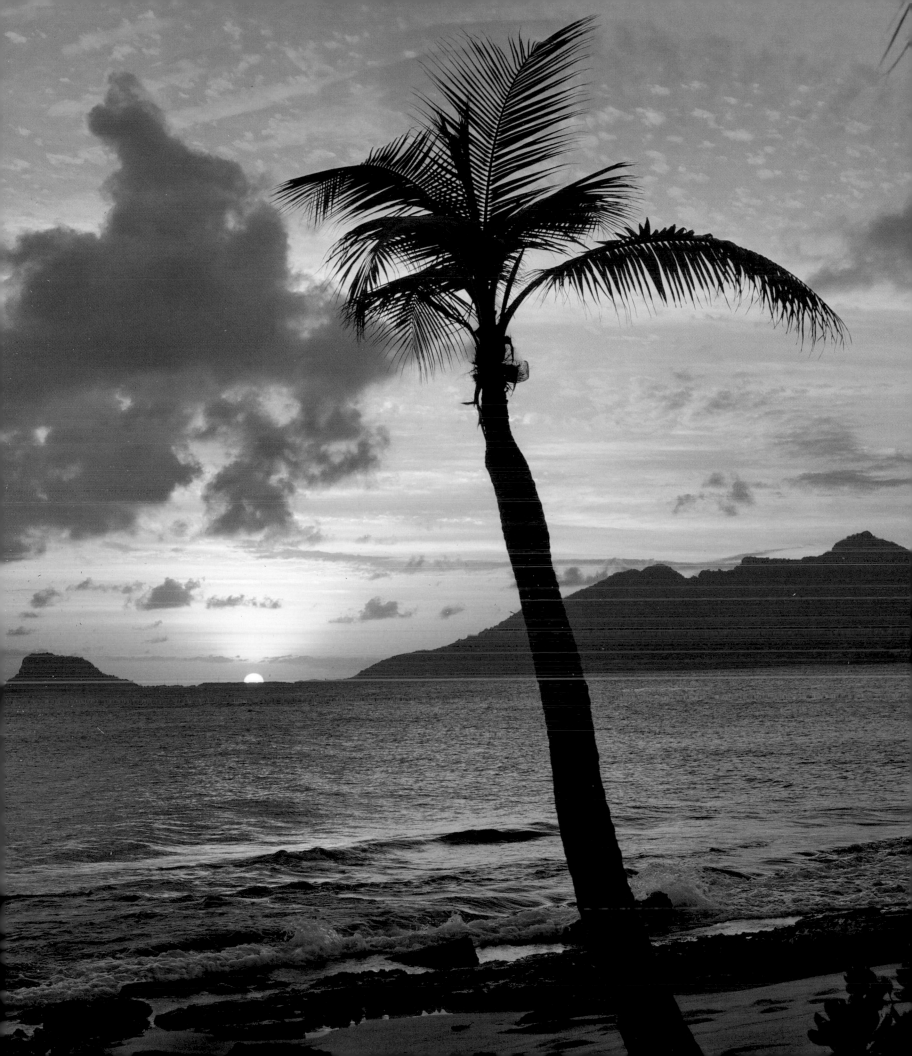

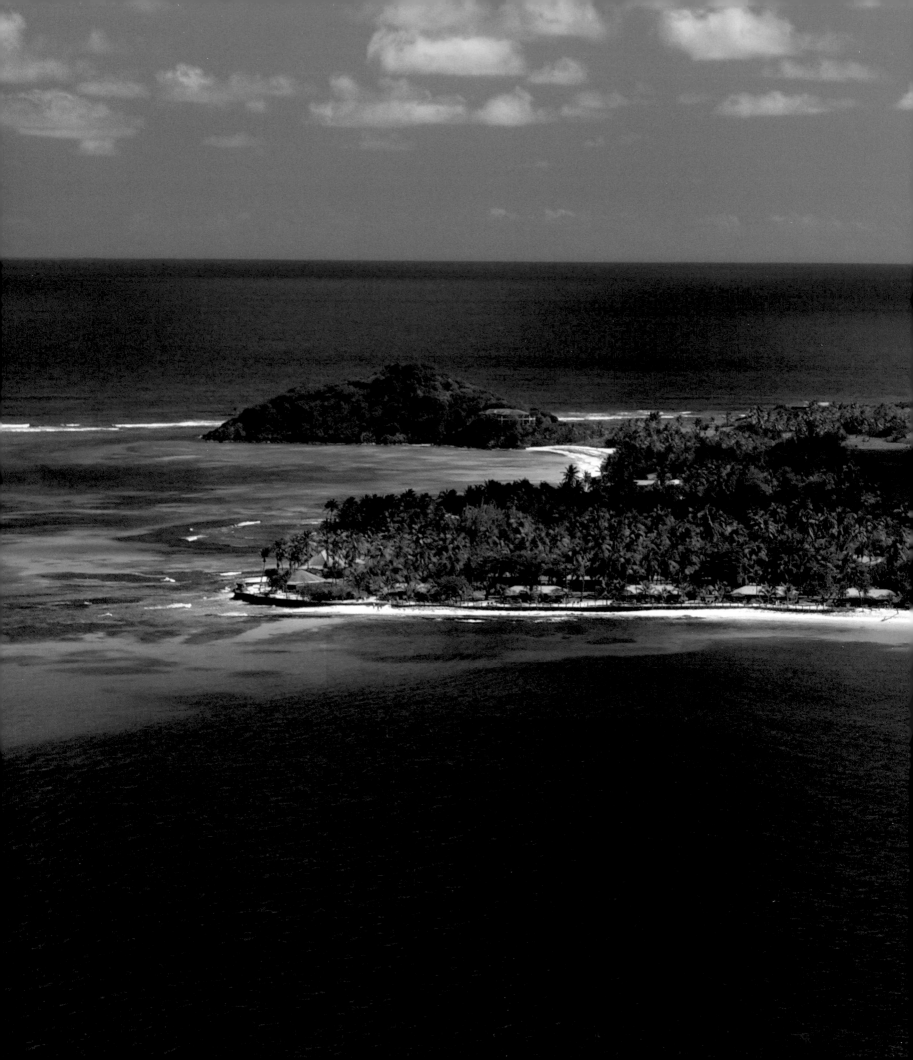

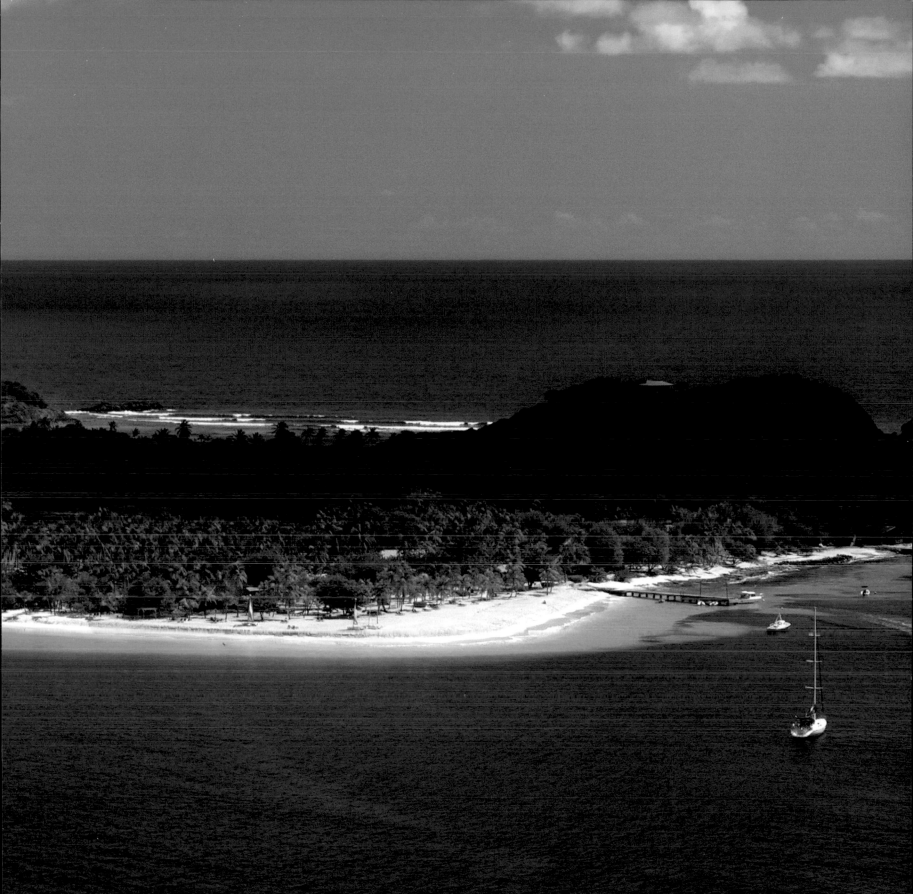

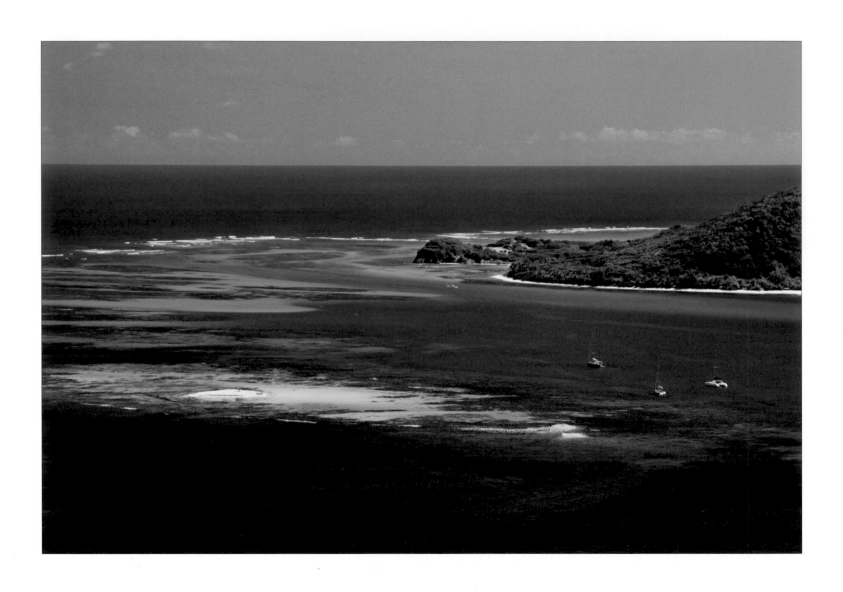

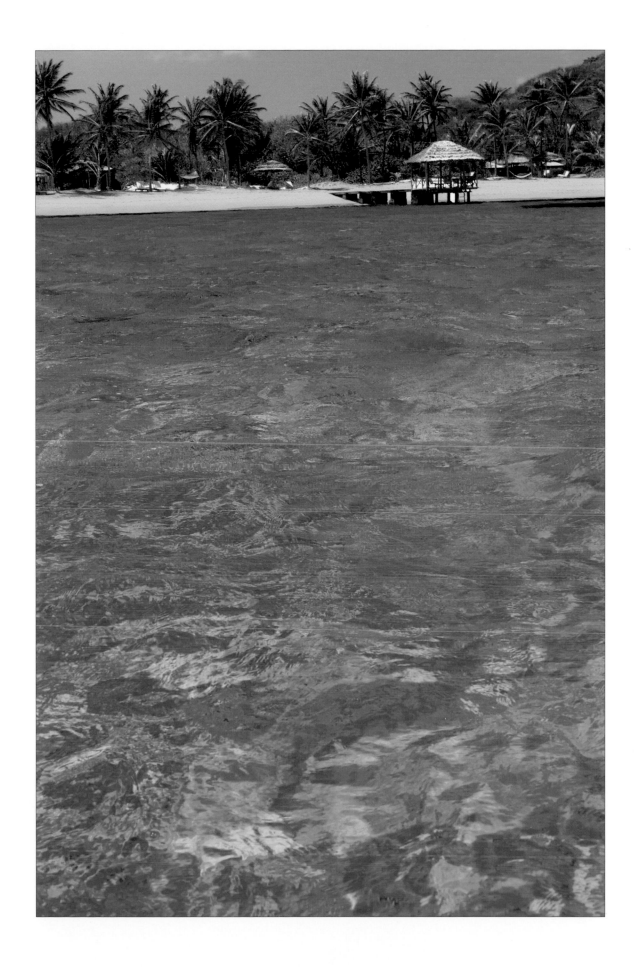

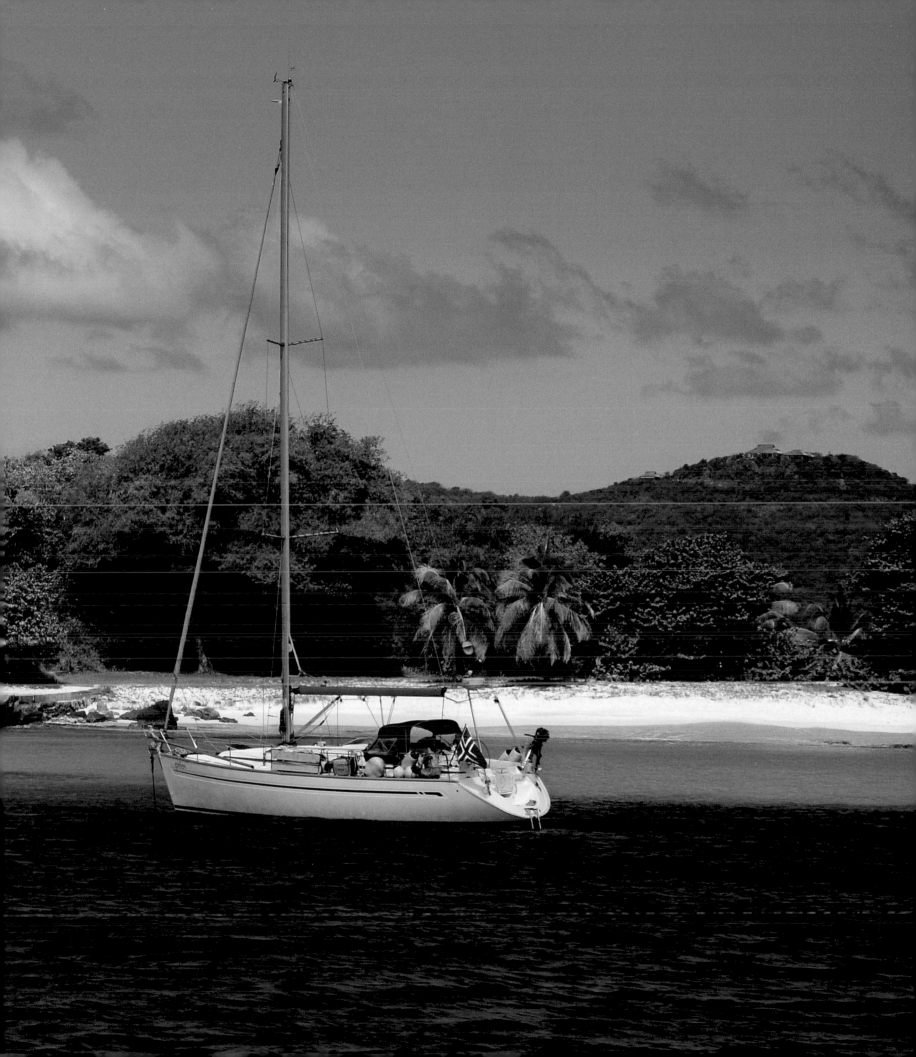

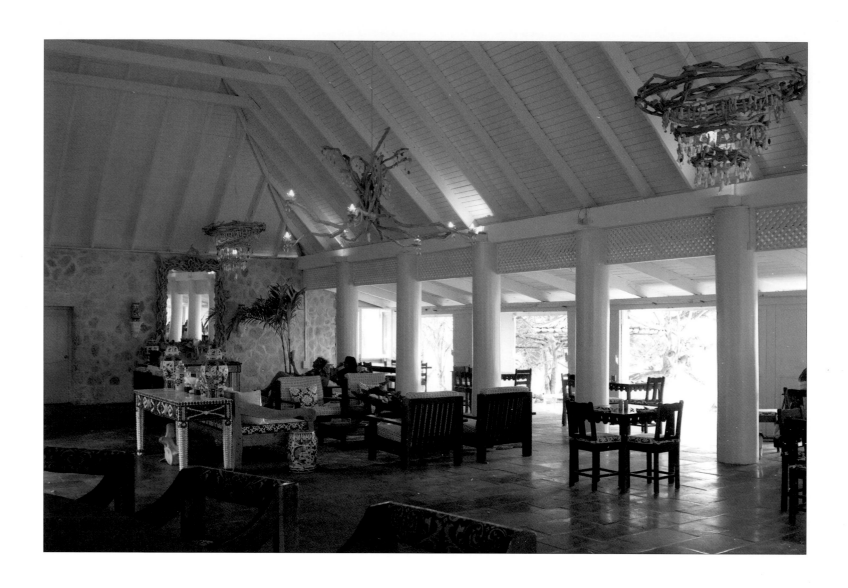

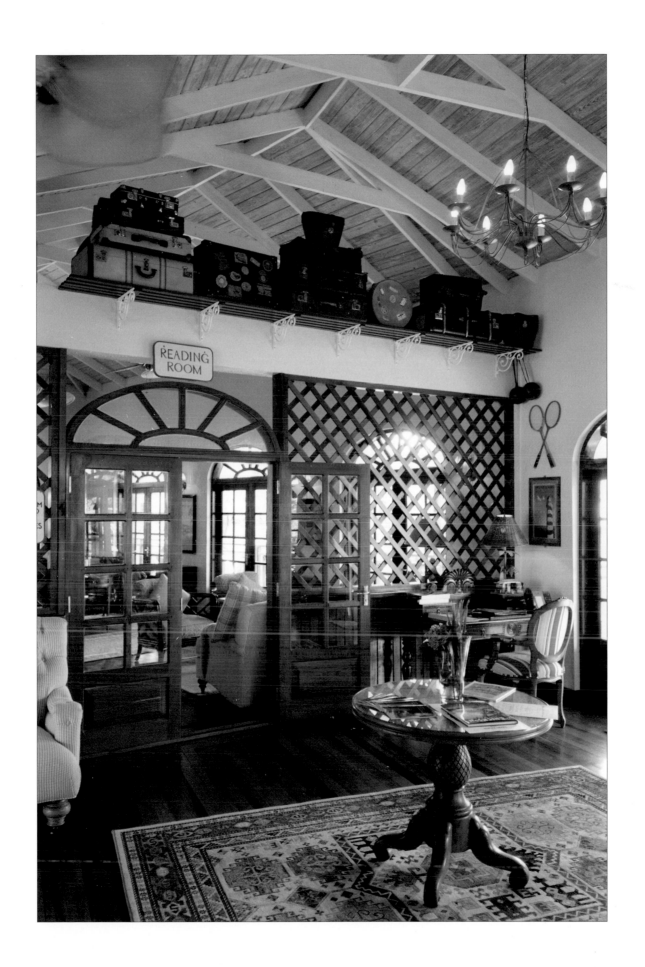

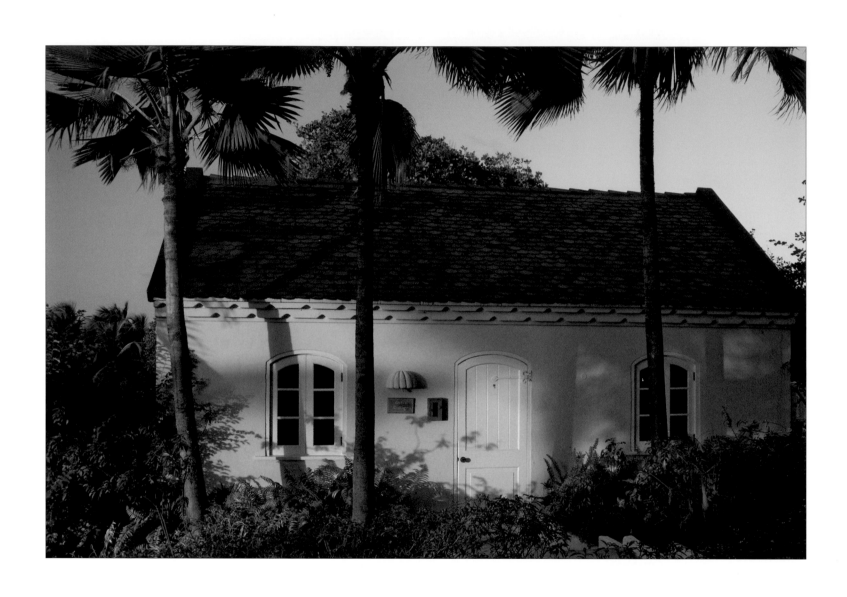

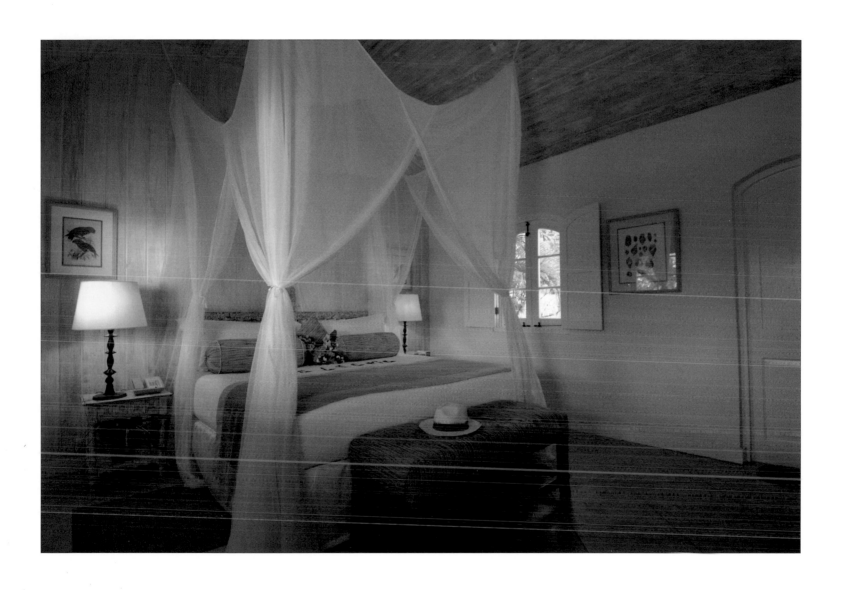

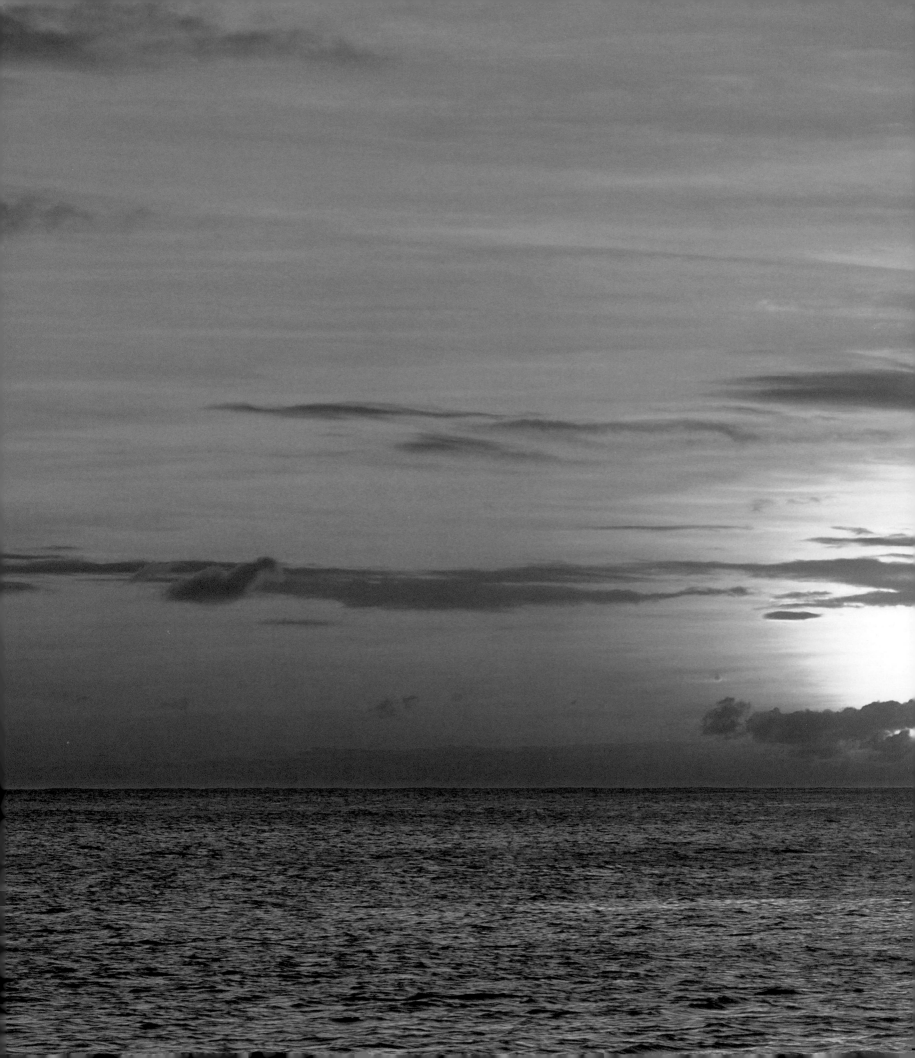

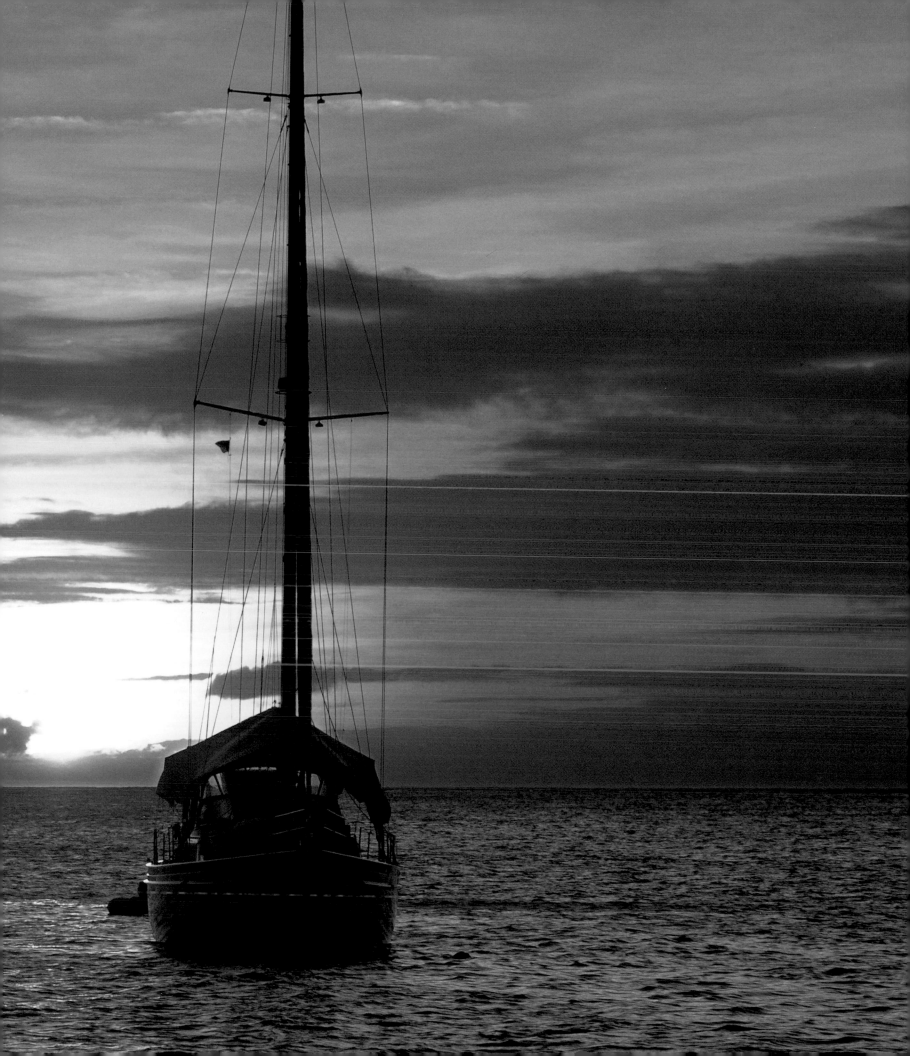

Captions

CAPTIONS

A Word of Thanks

THERE ARE MANY PEOPLE whose assistance made this book possible, and the work both memorable and adventurous. I'll give thanks in chronological order from the beginning of the project.

In New York there was Chris Spring the most unflappable and consistent liaison, and his colleagues Jennifer Reisfeld, Leslie Knobloch and Lydia Cady, instrumental in coordinating the long and complex trips. Also in New York was my associate, Céline Little, who worked on organizing and photo editing.

In the islands, I want to give thanks to the St. Vincent and the Grenadines Tourism Authority (SVGTA). Specifically, Glen Beache provided help rain or shine; Kathique Haynes and Marlon Joseph, who guided me through the islands and immersed me in their culture; Andrew, the encyclopedically-informed driver; and Timothy Vaughn who has created the marvelous Montreal Gardens.

Bianca Porter of Young Island Resort was better than a mom; John West, owner of TMM Yacht Charters was the generous supplier of a photo-yacht with a most able skipper; Bengt Mortstedt, the thoughtful architect and owner of Bequia Beach hotel; Eleonore Astier-Petit, at Mustique's Cotton House, who for a week became my tireless producer; Ronnie Wood who did an unforgettable impromptu guitar performance at Basil's Bar; Cinzia Occioni and Angelo Gulotta, both wonderful company, who run Tamarind Beach Hotel & Yacht Club on Canouan; and Andrea, one of Union Island's natural beauties who made work easy and fun. Then there was Nicholas, owner of Captain Gourmet, arguably the world's calmest pilot who half-dismantled his old high-wing for me to turn it into the ideal photo-plane.

There were the hotels who generously hosted me—images of them, with descriptions in their own words, follow.

In Tuscany and the islands, there was dear Candace who assisted with photography and designed the book. And in Verona were the printers: Enrico Battei who untangled the mystery of colors and enigmas of life; Georgio of Alfacolor who did color correcting and proofing; and Francesco, the owner of Verona Offset who put his heart into the printing of every page.

BUCCAMENT BAY RESORT

Buccament Bay Resort is a brand new 5-star hotel from Harlequin Hotels & Resorts. The all-inclusive luxury beach property is surrounded by a lush rainforest and a beautiful white sand beach. Buccament Bay Resort is the perfect holiday destination for travelers of all ages, offering a variety of activities to cater for all interests, including the Liverpool Football Club Soccer School, Pat Cash Tennis Academy, the Harlequin Performing Arts Academy and The Spa with treatments by ESPA.

Location: Buccament Bay, St. Vincent
Website: www.buccamentbay.com
Telephone: 784-457-4100
Email: reservations@buccamentbay.com
Nearby Dive Center: Indigo Dive

GRENADINE HOUSE

Grenadine House overlooks the vibrant capital of Kingstown in St. Vincent, and boasts a convenient 10-minute drive from the E.T. Joshua airport. It is complemented by 20 well-appointed guest rooms, all equipped with a queen sized bed, air-conditioning, high-speed Internet, and a safety box. The hotel also features the historical Sapodilla dining room, the elegant West Indies Cocktail Bar, and the Terrace with panoramic views of the archipelago.

Location: Kingstown Park, Kingstown, St. Vincent
Website: www.grenadinehouse.com
Telephone: 784-458-1800
Email: info@grenadinehouse.com
Nearby Dive Center: Dive St. Vincent

YOUNG ISLAND RESORT

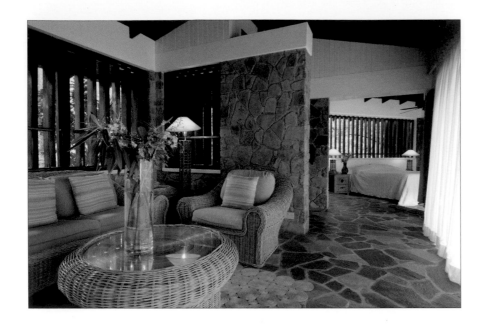

Young Island Resort, a 13-acre private island, is an enchanting paradise of lush gardens and secluded beaches. Each private cottage has an ocean view, with some offering private plunge pools and gazebos. Just off shore is the "Coconut Bar" where drinks are served in fresh coconuts. Dining at Young Island is an exquisite experience: fruits and vegetables are in abundance, as well as the freshest of fish, poultry and meats, and each meal comes with the resort's famous six loaves of bread—white, coconut, banana, raisin, cinnamon, and wheat. Private dinners can be arranged in the privacy of one's cottage or under a thatched kiosk along the waters edge. The on-site Spa Kalina offers treatments and pampering to cap off a perfect day.

Location: Young Island Cut, Young Island
Website: www.youngisland.com
Telephone: 784-458-4826
Email: reservations@youngisland.com
Nearby Dive Center: Dive St. Vincent

BEQUIA BEACH HOTEL

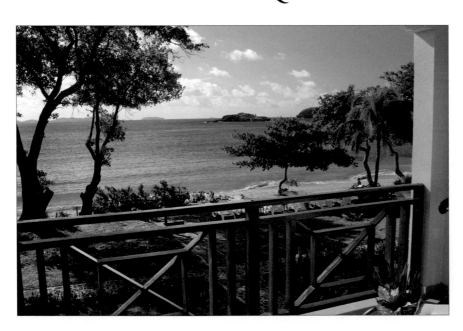

The five-star Bequia Beach Hotel is situated in what many consider to be the premier location on the island of Bequia—Friendship Beach. Inspired by Oliver Messel's stylish Mustique villas and surrounded by beautiful tropical gardens, this boutique hotel combines luxury, elegance and charm to provide a relaxing and friendly atmosphere. With an infinity pool, first-class restaurant and its own secluded sandy beach area, the property boasts 41 suites including an expansive penthouse, three two-bedroom villas with private pools, three bungalows and 11 rooms. The hotel prides itself on friendly service and providing an atmosphere reminiscent of the West Indies of the 1950s: casual yet elegant.

Location: Friendship Bay, Bequia
Website: www.bequiabeach.com
Telephone: 784-458-1600
Email: info@bequiabeach.com
Nearby Dive Center: Dive Bequia

Cotton House

Located on the Grenadine island of Mustique, the Cotton House (the island's only full-service hotel) is situated on a picturesque hillside surrounded by the Caribbean Sea to the west and the Atlantic Ocean to the east. The Cotton House has long enjoyed a reputation as an elegant private retreat for sophisticated travelers, celebrities and even royalty. Originally an eighteenth century cotton warehouse and sugar mill, the Cotton House was carefully restored by the late British designer, Oliver Messel. Today, this beautiful 13-acre retreat is recognized as one of the Caribbean's leading luxury resorts.

Location: Endeavor Bay, Mustique
Website: www.cottonhouse.net
Telephone: 784-456-4777
Email: reservations@cottonhouse.net
Nearby Dive Center: Mustique Watersports

Tamarind Beach Hotel

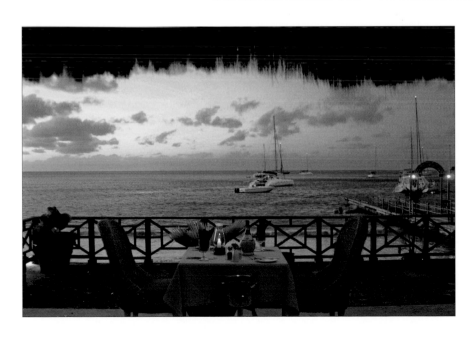

Tamarind Beach Hotel & Yacht Club offers an intimate feel with 40 beachfront rooms and suites. From all-meal dining at the Palapa Restaurant and informal bar and restaurant, Pirates Cove, to the Sea Grape massage room and private jetty—guests here are pampered at every elegant turn. Tamarind Beach Hotel & Yacht Club remains at the forefront of barefoot luxury in the Grenadines with its outstanding combination of seclusion, total relaxation, gourmet dining, first-class sailing and water sports, and of course pure white sands just steps away.

Location: Charlestown, Canouan Island
Website: www.tamarindbeachhotel.com
Telephone: 784-458-8044
Email: reservations@tamarind.us
Nearby Dive Center: Canouan Dive Center

PALM ISLAND RESORT

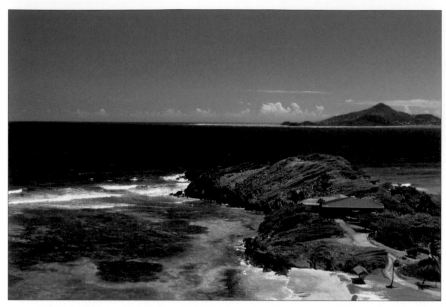

Palm Island (Private Island) ~ info@palmislandsvg.com ~ Tel:784-458-8824
www.palmislandresortgrenadines.com ~ Dive Center: Grenadines Dive

Palm Island Resort is an eco-friendly, green certified, 135-acre private island resort nestled amidst five white sand beaches offering a range of amenities, activities, dining options, and accommodations.

It features 43 guest rooms, of special note being the Island Lofts that sit above the water on five-foot stilts. The island's accommodations are delightfully free from televisions and phones and feature king-size beds, peaked ceilings, large verandahs and hammocks. Nature lovers can enjoy the secluded setting by sunbathing on the pristine beaches, and those seeking opulent pampering can look forward to a rejuvenating treatment at the on-site spa. The island's abundant sea life, coral reefs and unique shipwrecks attract recreational sailors and divers from around the world. The resort features a lagoon-style swimming pool, complimentary tennis, croquet, table tennis, beanbag toss and horseshoe game pit, cycling, shuffleboard and water activities such as kayaking and windsurfing.

PETIT ST. VINCENT

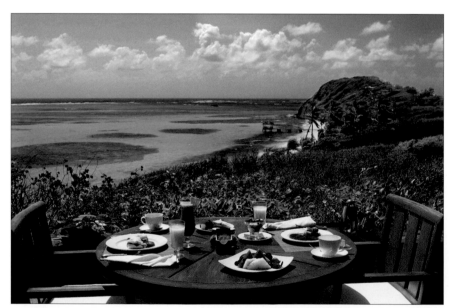

Petit St. Vincent (Private Island) ~ info@petitstvincent.com ~ Tel: 954-963-7401
www.petitstvincent.com ~ Dive Center: Grenadines Dive

The recently renovated Petit St. Vincent (PSV) is probably best known for being completely un-plugged. Once on-island, guests can count on total privacy and barely a trace of the world from which they escaped—no televisions, phones, casinos, and not even room keys. Being un-plugged does not mean doing without the finer things in life on PSV. The 22 cottages spread over 115 acres are built with natural stone found on the island and feature terra cotta floors, wooden sundeck, separate bedroom, bathroom and a dressing room. With a ratio of two staff for every guest, every need is met with a wave of a flag—literally. Hoist a red flag for zero disturbances. Hoist a yellow flag for the services of a staff member.